WINSLOW
THROUGH TIME

Charlie Close

AMBERLEY PUBLISHING

Dedicated to my late mother.

First published 2009

Amberley Publishing Plc
Cirencester Road, Chalford,
Stroud, Gloucestershire, GL6 8PE

www.amberley-books.com

British Library Cataloguing in Publication Data.
A catalogue record for this book is available from the British Library.

ISBN 978 1 84868 712 7

Typesetting and Origination by Amberley Publishing.
Printed in Great Britain.

Introduction

Until it became a commuter town, not many folk had heard of this little North Buckinghamshire market town. North Buckinghamshire was pretty remote and covered in dense forest. One newcomer, the late Joan Stewart, told me that she and her husband had been advised not to retire here because it was 'bow and arrow' country in North Buckinghamshire.

The fifth and sixth centuries brought missionaries, struggling to re-establish Christianity in the small competing kingdoms that made up the British Isles. Winslow was part of the Kingdom of Mercia, ruled by Offa. He is said to have chosen the town as location for a palace on Dene Hill, near where the A413 enters town, from Aylesbury.

Offa wasn't very nice. In 792 King Ethelbert of East Anglia paid Offa a friendly visit. Because Offa had designs on Anglian territory, he killed him. It's funny how we look up to royalty. Offa's conversion to Christianity followed to Catholicism followed a brutal period of Saxon rule. Apparently guilt stricken, Offa began taxing his people to raise money for the Catholic Church.

It is more probable that Offa realised that religion was useful in controlling people through the fear of God. A monastic cell, or Grange, was established at Biggin, just west of the road to Granborough, before the bridge. Charlemagne knew the process well. He was preaching the Gospel by sword and taught the Saxons all they knew. He sheltered Egbert in exile from Wessex.

Egbert learned well and became King of all England in 828. Kings had to be ruthless to survive and rule. The Pagan threat lingered on and was encouraged by the Vikings. By 912 the Norsemen were calming down. They made use of Christianity. For services rendered, Rolf the Ganger gained land on the north coast of France. This became Normandy. It was from here that William the Conqueror came in 1066.

Celts were more horticulturists than farmers were. Better seeds and tools changed ways gradually. The Celts were loathe to leave when the Saxon's came and their influence endured long after William the Conqueror brought the class conscious feudal system. The Saxon ridge and furrow was well established by this time.

The new King of 1066 didn't do badly for being the bastard son of the Duke of Normandy and Arlette, a tanner's daughter. Even so the wholesale enclosure of the three-field system – Winslow cum Shipton was actually six fields – did not arrive here until well into the nineteenth century.

Rich landowners were able to use their control of state processes to steal appropriate public land for their own benefit. It met with resistance and ended the ancient system of arable farming and parallel system of common meadows.

A lot of common land was lost. Consequently a landless working class was created which provided labour for the new industries. Winslow, however suffered a lot less from these pressures, though the railways at Bletchley and later on McCorquodale's print works at Wolverton drew

many folk Northeast to those towns. Bletchley expanded at the end of the nineteenth century and throughout the twentieth century. It is only nine miles north east of Winslow. At first it offered opportunities only in brush factories and brick works. The latter attracted many displaced rural workers during the agricultural depression of the 1890s.

Winslow, however, benefited from country sports and there were opportunities working for rich landowners like the Lowndes family who had Winslow Hall built in 1701. It was constructed from locally made bricks, excavated from a site near the old County Secondary School.

The silliest explanation for the origin of the name Winslow was broadcast on a TV series called *Heart of the Country*. It was suggested that it came from a family name and that Terence Rattigan wrote the Winslow boy here. The true origin is more obscure. It is most likely to have derived from two words, Wini and Slai, meaning low hill.

Studies have shown that the town's origins lay somewhere along the road to Swanbourne. The Parish reaches its highest point of 409 feet above sea level, about three-quarter miles along this road. Near this point, a bridleway forks left and was once part of a road to Mursley – then an important settlement – and Bletchley. Salt traders from Wales used this as a way to the Roman Watling Street – the A5 and London. They called at towns along their way to do their business.

Further Southwest, at what locals call Tinker's End, there is also evidence of an important settlement. Both areas were ideally suited to growth, high above a fertile clay vale. The southern end of the parish is clayey loam on Oxford Clay. Further north is sandy with veins of gravel and limestone. The whole area is drained by a number of underground springs flowing into Shipton and Claydon Brook a tributary of the Ouse. The main brook flows to the south under the Little Horwood Road and along the edge of the present Magpie estate, which was farmland until the 1970s. The landscape rises gently between these streams, to 292 feet in the east, 325 feet in the north and 416 feet in the west.

The precise pattern of how many scattered settlements became one can't be plotted. Shipton used to be a very separate place, with evidence of many separate house platforms. At least 12 dwellings stood at the brow of Shipton Hill. When a new bungalow was being built on Shipton Hill, at Rand's Farm, a thirteenth century cooking pot was discovered. More medieval pottery was found 1155 feet ENE at Shipton Farm.

In 1934 four skeletons were discovered in sandpits near the row of cottages on the A413 – almost opposite in fact. A Home Office investigation concluded that the remains were actually Britons or Saxons who had died in battle. It was suggested that the bodies had been properly buried and that a church may have been nearby. Locals suspecting murder must have been sadly disappointed.

The Saxons were put in their place by King William's reign of terror. With the help of 6000 knights, he brought order to a land of 2 million Saxons, Celts and Danes. Among the Norman invaders was the first of a long line of Lowndes. This family was to play a big part in the history of Winslow.

By the thirteenth century, Winslow had 25 cottages clustered around 25 cottages. Fuel and building material was gathered from woodlands. It prospered and Henry III granted a Market Charter in 1235. The charter allowed a weekly market and a fair on the Feast of St Laurence. Surrounding plough lands were divided into six big open fields.

Regular passage of traders through North Buckinghamshire meant vulnerability to plague. Black rats like travelling in grain wagons. A flea lived on this rat. It passed on bacillus pasteurrella when it bit people, giving them the plague. Contemporary medicine was useless. In 1348-9 it struck a population under 4 million, hitting the lower orders hardest.

Agriculture collapsed, leading more land to be left to pasture around Winslow. Famine followed plague. Peasants were obliged to grind corn for the Abbot at St Albans. Winslow peasants were too down trodden to join in a rebellion. It was just as well as Richard III put the rebels down, telling them: 'Villeins ye are and villeins ye shall remain.'

The site for Winslow's church was chosen in a woodland clearing, where Saxons may have worshipped in the temple of Woden or Witen. The Church was central to repression. The stately Norman prelate, Bishop de Craversande of Lincoln, with a following of mailclad knights and bishops, dedicated St Laurence Church.

Unlike the ruthless powers behind the church, the man it was named after was rather nice. In the third century, during the Valerian persecutions, the Archdeacon of Rome asked Laurence to deliver up the church's treasures. Laurence responded by bringing a gathering of his poor. The emperor was furious and Laurence was burned alive on the gridiron. He is said to have died with an expression of an angel – refusing to condemn his murderers.

In the nineteenth century, vicars were genteel, influential and tended to ape the gentry. The modest but elegant St Laurence Church, with its early English arch, was no place for common folk in the nineteenth century. Very kindly, Mr Chinery of Winslow Hall, had two tin tabernacles built at each end of the town for the common folk to worship in. The Congregationalists and Baptists also had their chapels in Horn Street and High Street respectively. The former is now a private house, but the latter still has a lively congregation under the leadership of Paul Duffett, who took over from his father Rev Duffett. There is also a Catholic Church, attached to the side of Winslow Hall. The last owner of the Hall was the late Sir Edward Tomkins – a Catholic himself.

By the end of the nineteenth century, the world was changing. Britain's empire was at its zenith, but challenged by Germany. Working people travelled only twenty miles from home at the most. Wars in Africa presaged worse problems in Europe. Winslow was still very rural, but London was only fifty miles away. Thomas Braseey brought 2000 navvies with him, passing through town building his branch line railway between Oxford and Cambridge. Brassey budgeted £200 for his men's religious education. Much of their wages were paid in kind – the notorious truck system. The first trains rolled through town in May 1851. Winslow was in easier reach of a wider world. Stagecoaches had been more a means of travel for the wealthy. In those days the Turnpike Trust looked after the road. It was variously a dustbath and a quagmire – also troubled by highway robbers. It was not an easy way to travel, but there was no other means until the railway in 1851. County Councils took over maintenance in 1888.

State Education arrived in the shape of a National School, near the old High Street Post Office, in 1870. The local rich expressed concern that religion should be a strong element of instruction to keep the working folk in check. A little further up the High Street, heading for Buckingham, the workhouse was still busy. It was affectionately known as 'The Spike', after a big spike used to break up hemp. This was part of the deal for a minimal level of food and accommodation. It

was a horrible place to be, but Winslow was lucky to have a decent workhouse master, Cyrus Evans. He was an old soldier with compassion for the many old soldiers calling on him. He copied the following words from one of the cell walls in September 1896:

'Of all sorts of business,
The cadgers are the best;
Because when he is tired,
He can sit down and rest
Here lies a poor beggar
Life always tired;
Fore he lived in a world
Where too much is required.
Friends grieve not for me,
That death does us sever;
For I am going to do nothing
For ever and ever.
Poor old M is dead and gone,
He's gone to a place
Where there's no breaking up stone.'

Life in Winslow for most people was hard. Snobbery and inverted snobbery were rife. It is not my purpose, in this book to look at Winslow through rose coloured spectacles, nor is it my purpose to gratuitously denigrate it. All I aim to do is to entertain and to show a little of the truth that underlines its history.

It is a series of snapshots through time, with some comment and description. Pictures tell their own stories. Thus, there is plenty of opportunity for readers to draw their own conclusions.

April 2009
Charlie Close

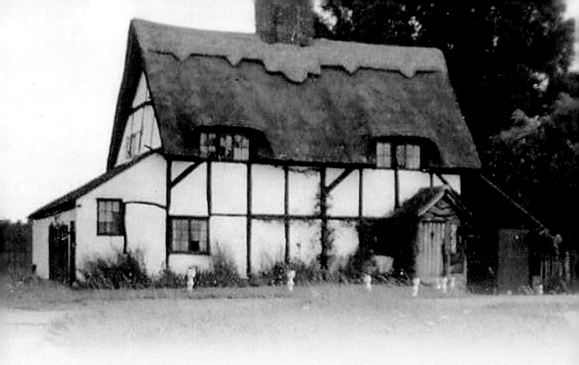

Shipton

Historically, Shipton was a separate settlement with many more houses than are present now. The A413 road into Winslow from Aylesbury crosses over Shipton Brook, a tributary of the Ouse. Shipton had its own system of three big fields. These were named Lin Hill Field, Blackgrove Field and Red Field. Shipton was undoubtedly a Saxon settlement, in my view.

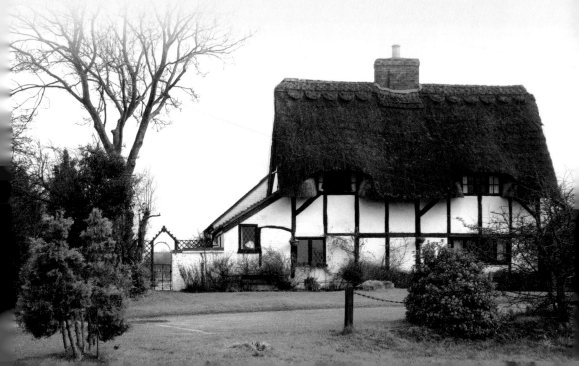

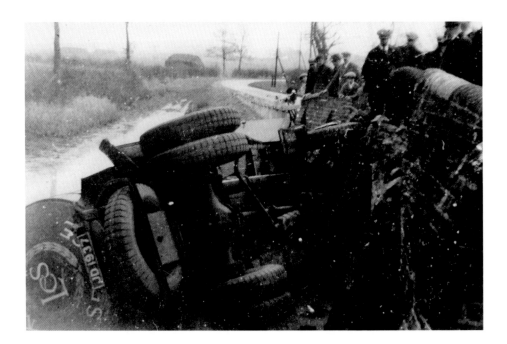

Winslow and District farmers sent their milk as far away as London for sale, before World War. One customer was the London Co-operative Society. In this picture we see a full tanker having gone out of control on the hump back bridge *c*.1933. I am told the brook was running white for some time. In those days lorry brakes were very inefficient and vehicles were getting bigger.

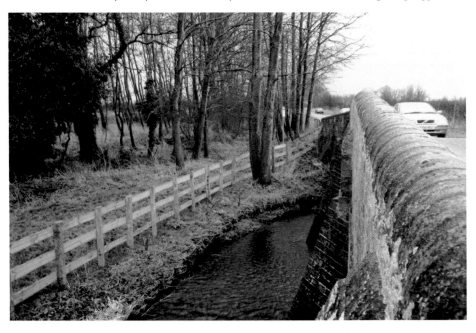

The scene at the bridge today is much the same. The area received a facelift to make it attractive for picnics. Unfortunately it has become popular with the modern pastime of 'dogging'. A picnic site sign was put up in the early 1980s, drawing traveller's attention to the roadside wildlife haven!

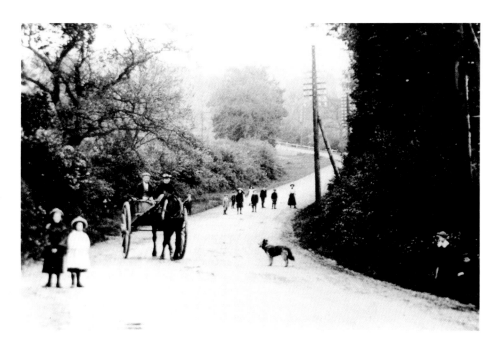

This pretty scene is c.1912. We are looking toward the old bridge and the road to Aylesbury. Shipton Brook was a popular playground for children up until the 1970s. (Terry Foley)

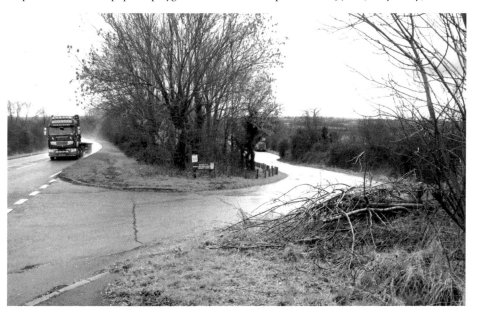

The same scene today shows the old road where it joins the new bypass section. British roads weren't numbered until a scheme was introduced in 1913 to ascertain quality and use and to allocate funding. Classification was interrupted by war, resuming in 1919. As a Class 2 road, the A413 got 50% national government funding. In 1931, a county structure plan envisaged by pass roads around many towns. The new section, along which the lorry is travelling, was the first stage of Winslow's bypass. World War Two interrupted further work. Local vested interests made sure the project was abandoned ever after.

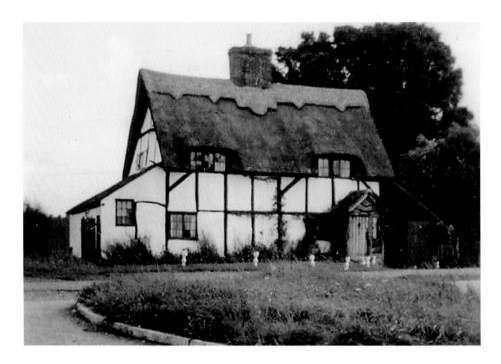

Rosemary Cottage at the top of Shipton Hill, *c.*1950. Norman Saving notes in his *Glimpses of Past Days*: 'I have...heard from more than one source that 'Rosemary Cottage' was at one time a small inn or public house, but alas! We have no record of it as such.'

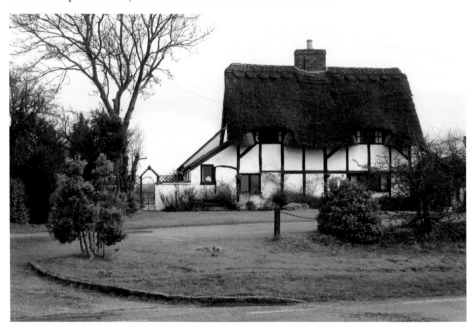

Rosemary Cottage in 2009. It sits on Shipton Hill as if in a time warp. It is a one and half storey structure, mostly infilled with wattle and daub. A surprising feature is the fine and ornate staircase. It rises from the kitchen end and features some beautiful barley twist stair rails dating from about 1725.

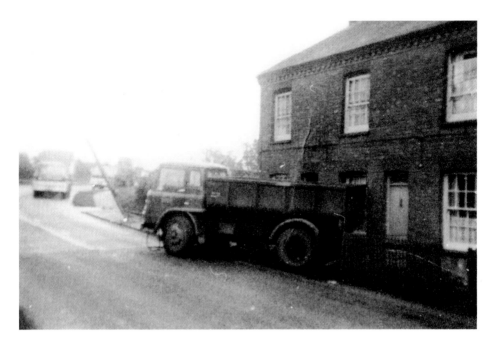

Jubilee Cottage, 1964. At this time, the old wartime runways were being broken up to return wartime RAF Little Horwood to more agriculture, after a period of being used as a crop spraying base. Halls of Pinner had their tippers on piecework. If the relief road project had resumed, the main road would have continued straight on, instead of taking an almost ninety degree turn into town. This driver lost control and demolished a cottage front. The corner is notorious for such accidents. Quite recently, a motorcyclist was killed and an off duty policewoman ran into another one of these cottages, demolishing a porch. (B. Spatcher)

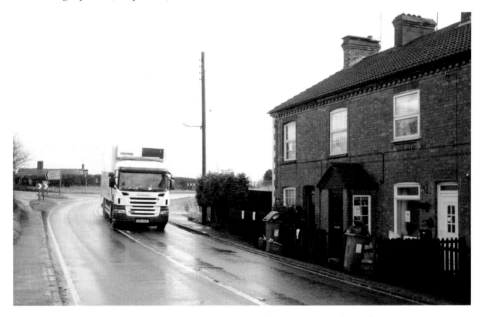

A3663 Food lorry safely negotiates Shipton Corner in March 2009. The relief road still has not been built.

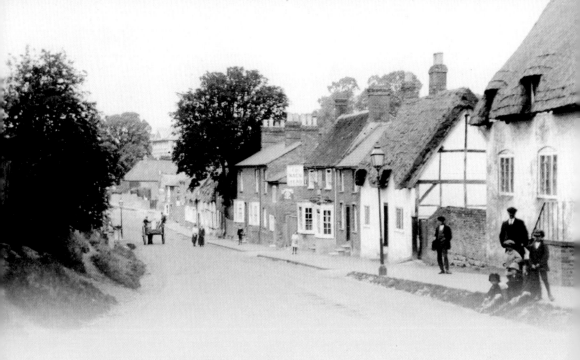

Sheep Street

Sheep Street takes its name from the days when drovers brought sheep in and out of town along this way. It was home to many of the farm workers who toiled on McCorquodale's estate. The McCorquodale family also lived in this street. They lived in Winslow Hall, which was built for Sir William Lowndes in 1701. The hall is said to have been designed by Sir Christopher Wren. Lowndes was known as 'ways and means' Lowndes, for his idea of debasing the coinage when the government got into financial troubles. His own family got into difficulty through bad estate management and sold the Hall to the McCorquodales.

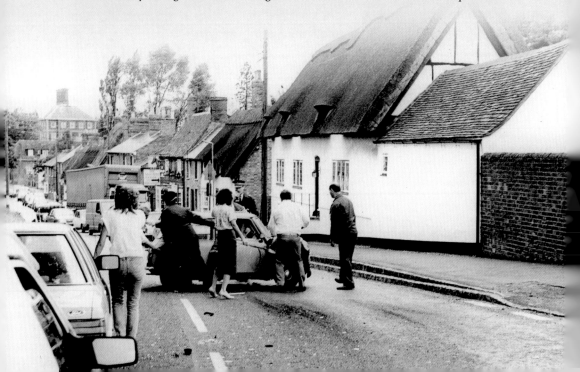

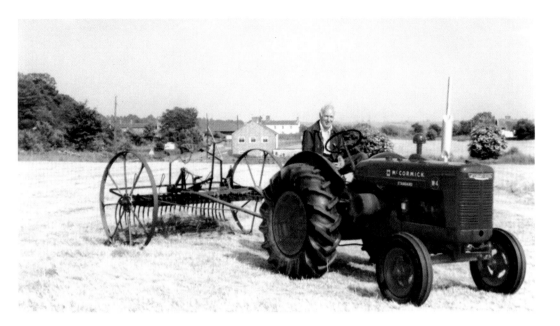

Farmer George French on his historic International Harvester W4 tractor in July 1987. He is farming on Dene Hill. Jubilee Cottages and Rosemary Cottages are visible in the background. This hill is officially inside Winslow town boundaries. The hills believed to have been the site of one of Offa's palaces and Dr Newham excavated valuable coins here.

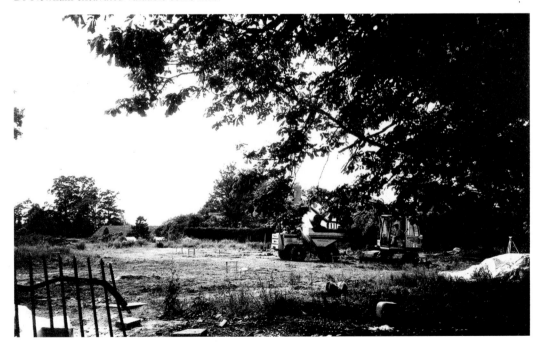

Clearing the old HORSA (Hutting Operation for Raising the School leaving Age) site in June 1996, ready for housing development on Dene Hill. Closing the school site was controversial. Bucks County Council's ownership of the land was disputed as the original land and building was paid for by the church and public subscription to replace the original school in the High Street.

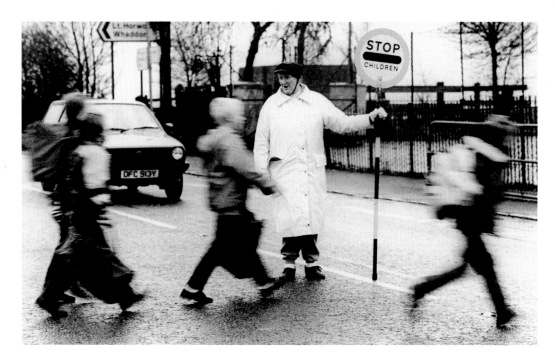

The A413, as traffic rushed in and out of town, was dangerous. In the late 1950s, a decision was made to employ a crossing patrol, later called 'lollipop ladies' because mainly women did the low paid, but dangerous job. However, the first person to do the job in Winslow, was Mr Keys. The first lady to do it was Gladys Cook, for £1 10 shillings a week – ten shillings less than Mr Keys because she was a woman. This picture shows Winslow school's last lollipop lady at work in 1990, just before the school closed.

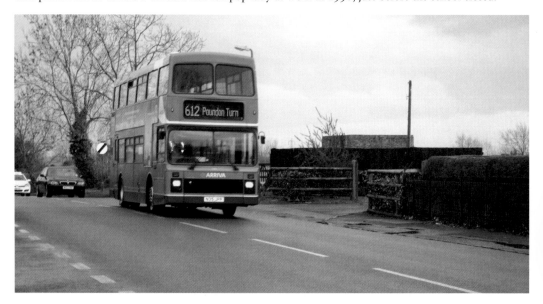

The same scene in 2009. An empty bus passes the spot on its way to collect schoolchildren six miles away in Buckingham. Bussing schoolchildren is now big business as youngsters are herded together in increasingly impersonal exam factories. The old Bucks water building is visible to the right – minus its skylight and falling into decay.

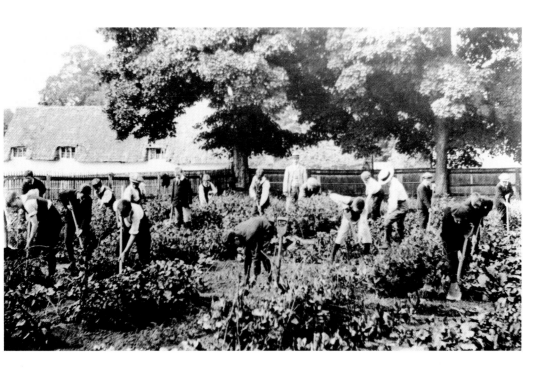

Winslow School gardens in 1915. The children are doing their bit to help a besieged nation at war, 'dig for victory' and are learning some useful future employment skills at the same time. Most people had small gardens, but their fathers often had allotments. Gardening skills would set them in good stead to help dad as well.

It is impossible to capture a totally comparable scene today, but the end of the thatch roofed cottage seen in the previous picture is just visible above the high hedge put in to protect the new houses from traffic noise and pollution from the increasingly busy A413.

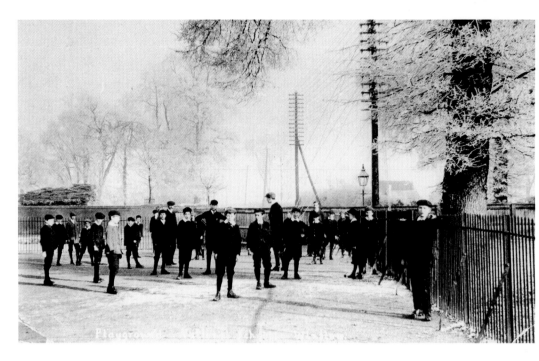

Looking toward the A413 and Little Horwood road junction, from the school playground *c*.1910. The important looking telegraph poles stand out in the frost.

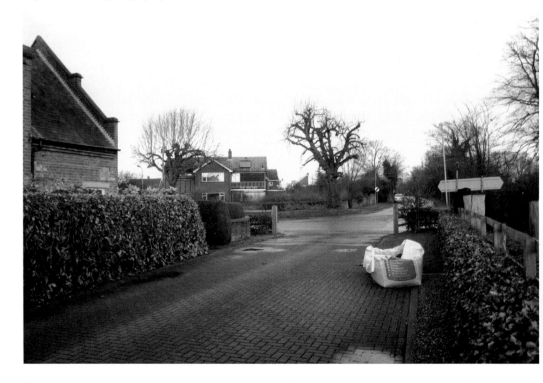

The same scene today puts us on the access drive to the back of the redeveloped school site. The road to Little Horwood and Milton Keynes is directly opposite.

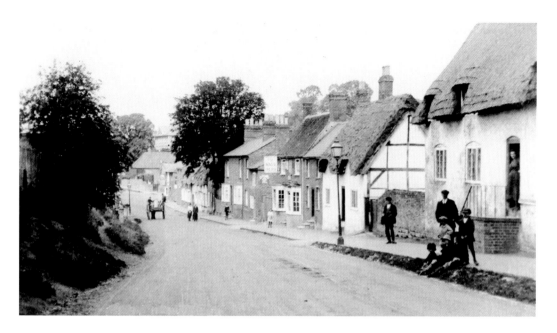

Looking down school hill, along Sheep Street *c.*1912. A few locals pose self consciously for the camera. It is a peaceful scene, but life was hard in those days. Thatched and bulging cottages were not the havens of modern well-to-do folk that they are today. War was also in the offing and many young men would soon be off to the slaughter.

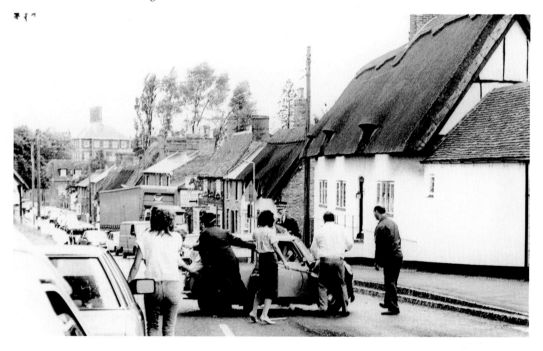

Just how dangerous this road has become is clear in this scene from July 1988. An articulated lorry broke down near the Nag's Head pub. It's clutch had burned out and with a heavy paper load it could not clear the hill. Motorists became impatient behind the lorry. It started to drizzle. One car pulled out and ran straight into a mini coming the opposite way.

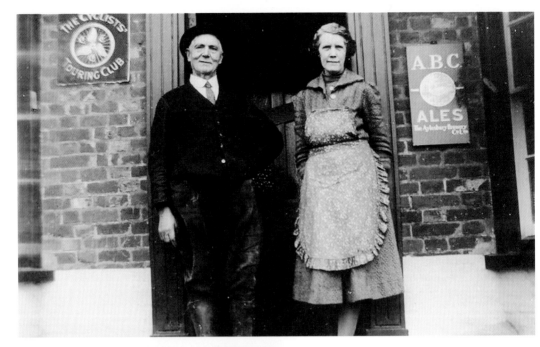

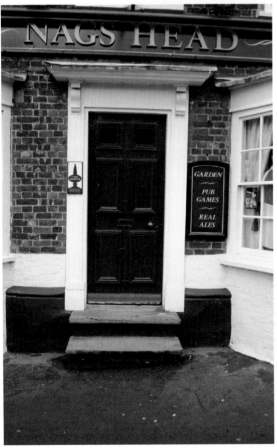

The Nag's Head was the focus for the street's people up until the second world war, when newcomers added to the mix. The Ansells, pictured here, were popular landlord and landlady of the pub.
The ABC sign refers to the long gone Aylesbury Brewery Company who owned the pub and provided the beverage.
The brewery was asset stripped in the Thatcher years and property sold off to developers.

These days, to attract drinkers, especially the more profligate young, pubs need a brighter image. However, the Nag's Head has done its best to remain traditional in a shrinking market. It is one of the few Winslow Pubs to have avoided closure.

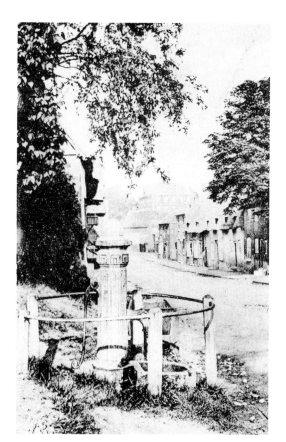

Before the mid 1930s, there was no electricity in Winslow and water had to be obtained from the various pumps dotted about. With so many springs draining off of Dene Hill, Sheep Street had its own pump, as shown here *c.*1912.

The same scene today shows a trace of the concrete into which the pump was set and a rare lull in motor traffic.

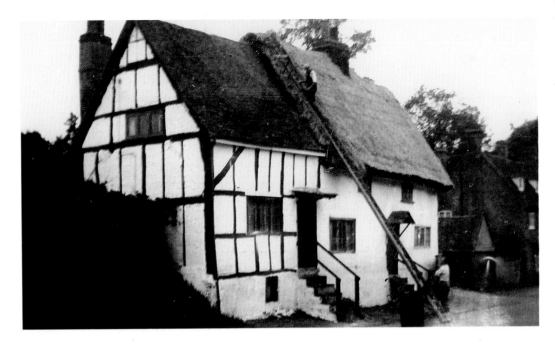

A thatched cottage at the bottom of school hill gets re-thatched in the 1930s. In those days skilled thatchers came fairly cheaply. Straw was a warm and cheap way of roofing in rural England. The French family owned these cottages. Bill French senior had been a chauffeur for McCorquodale before starting his garage and taxi service. After the war, he started 'Winslow Coaches' with his son, also Bill. It was a tight squeeze getting the buses through the narrow gap next to the thatched cottage.

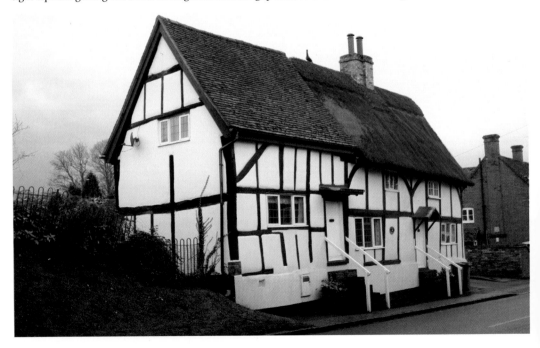

The cottages in 2009. They were almost completely demolished and restored and along with the Winslow coaches building, redeveloped for housing in 1988.

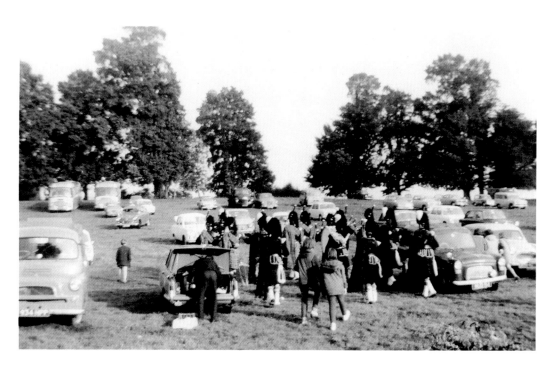

The St Albans pipe band beat the retreat from Winslow Show in Home Close, 1967.

The same scene in 2009 looks little different. Wind and time have removed some of the trees, and the leaves have yet to mark return of Spring and Summer. Bill French and his Oddfellows Club started the first show and gymkhana in 1960. The Oddfellows Club is no more and both Bill Frenchs have passed on, but the show goes on.

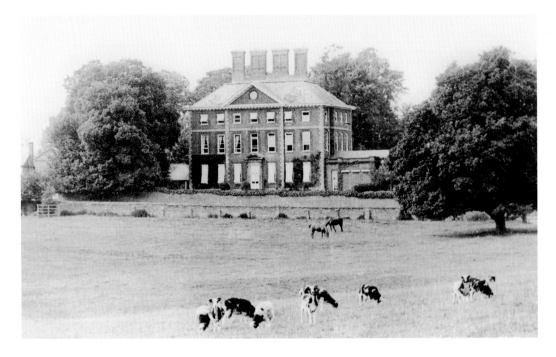

Winslow Hall in the early twentieth century, Shutters protect the downstairs windows from summer heat. The cattle feast upon the pasture of Home Close.

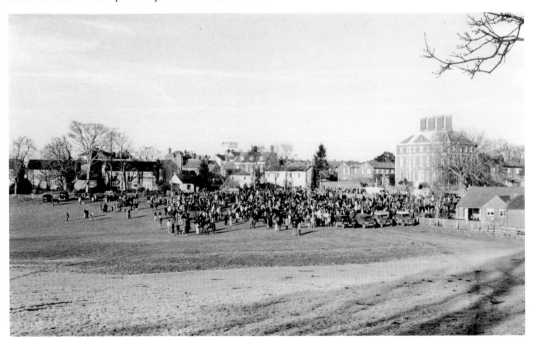

Home Close Boxing Day 2006. The New Labour Government, disinterested in the effects on the rural economy and Countryside Alliance protests has banned hunting, because rural voters aren't traditionally Labour voters. It is a gloriously sunny morning and frost is on the higher sheltered land. The popular Whaddon Chase no longer hunts, but makes a symbolic annual meet in Home Close.

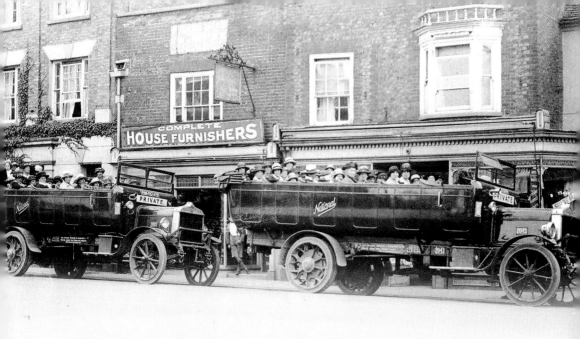

Market Square and
High Street

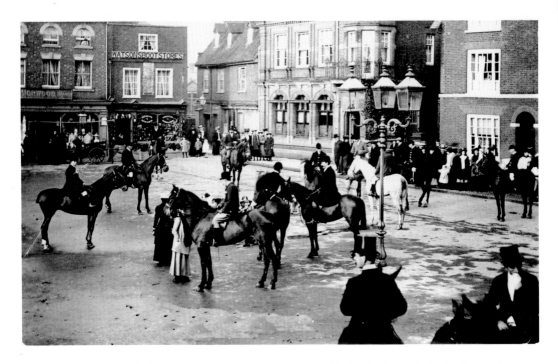

Looking west at the Whaddon Boxing Day meet in 1907. The Bucks & Oxon Bank dominates the streetscape. It was built by Aylesbury's Webster & Canon and opened in 1897. Watson's boot store is in the far right hand corner, next to Horwood's, which would soon become the Co-op.

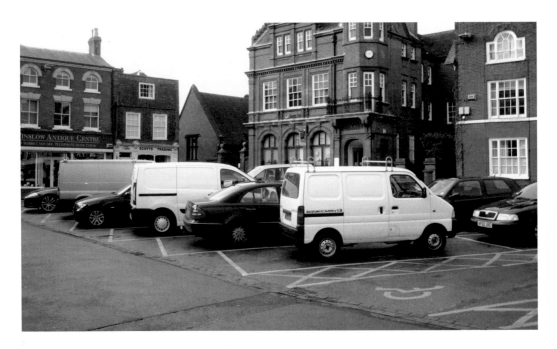

The square's building line is the same in 2009, except for the old buildings in the far right hand corner being demolished to make way for the church robing room in 1910. It functions mainly as a car park, with the rump of a market on Wednesdays.

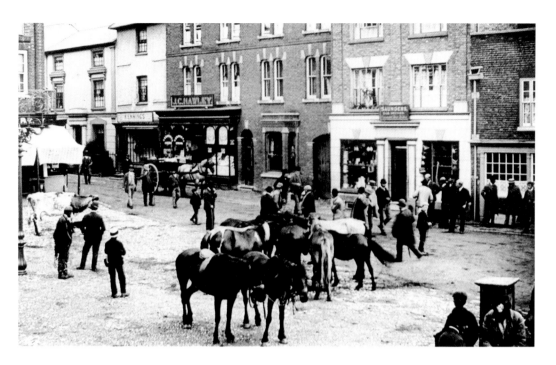

Horses from Wales are on sale in 1911. Hawley's grocery store is far left.

Roughly the same viewing point today shows the dominance of cars, with little change to the buildings. Hawley's have made way for a succession of supermarket owners. Dudney & Johnson took over in 1959, bringing Green Shield ladies and stamps. Civils and Zull Kaswani followed. The shop is now One Stop part of the Tesco empire.

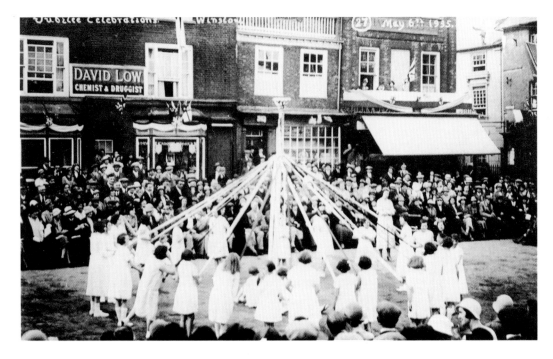

Maypole dancing as part of King George V's Coronation celebrations in 1935. The building far right on the square is reputed to have been built by Wren. It was demolished in 1948 to make way for buses leaving the square. The space vacated is mainly occupied by very wide pavement.

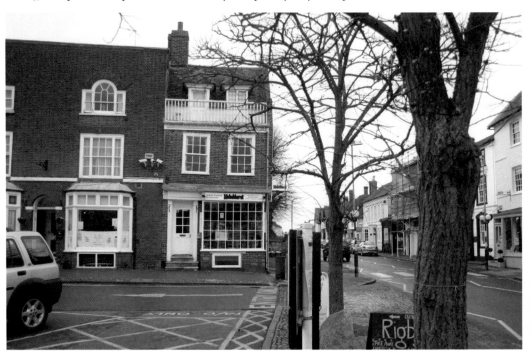

The same scene in 2009 looks similar except for the demolished Market House. The Indian restaurant in the centre of the picture is excellent.

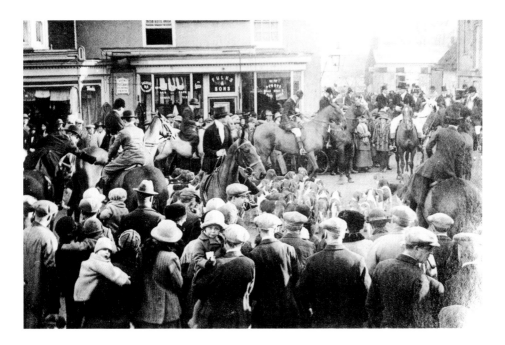

Whaddon Hunt meeting, January 23 1925. This image affords a good view of Fulks shop before the building was realigned to ease the dangerous corner. The Prince of Wales had taken to riding with the Whaddon due to foot and mouth on the Quorn and friendship with the Bishops of Roddimore Stud. He stopped because farmers Bert and Syd Illing fired shotguns to frighten the fox away – offending the Prince with bad language.

In 2009, we notice that the shop front has been angled back and that the corner premises are no longer part of Fulks'. Fulks' sold men and women's garments, furniture and bicycles.

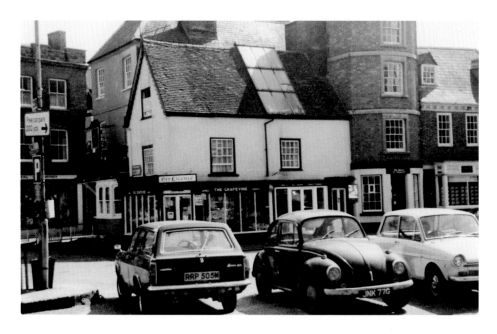

Market Square mid 1980s. The centre building was Beckett's bread and cake shop. The Bakery was in Horn Street. Geo Wigley's offices are far right. The building with the skylight was Turnham's shop, the skylight being vital for his photographic studio at the turn of the century. The family had a sweet shop down below. This passed to the Beane family when Molly Turnham married Major Charlie Beane. It became the Grapevine off-licence in the early 1980s.

The same scene today shows two dormer windows, as offices have been created in the studio space. The bread shop has closed, along with the off-licence, which had been taken over by Threshers.

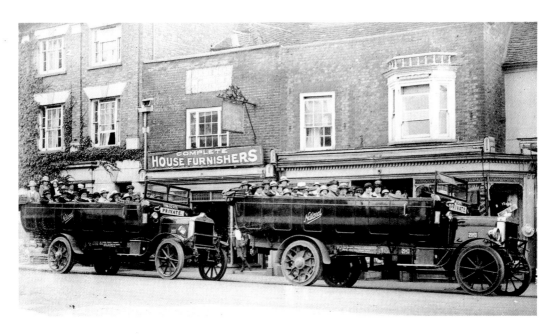

Charabancs belonging to the National Bus Company collect passengers for a Women's Institute outing to Windsor in 1923.

This view shows the whole frontage of the former Fulks' Winslow superstore. Large shops could survive in a small town as travel was more challenging until the 1960s.

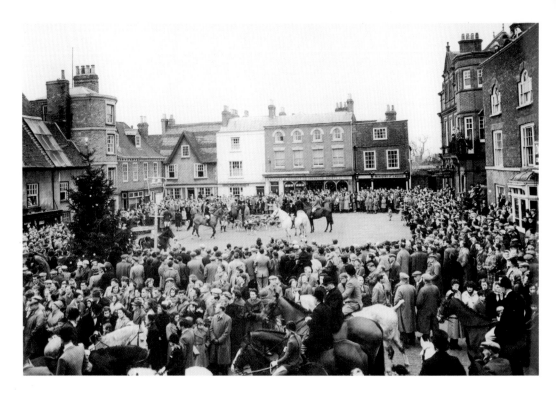

Boxing Day hunt gathering, 1958. Whaddon Chase drew a large crowd. The large shop in the centre is the Bletchley & District Co-op shop. The smaller building to the right is the Labour Exchange, established in the old boot shop after World War Two.

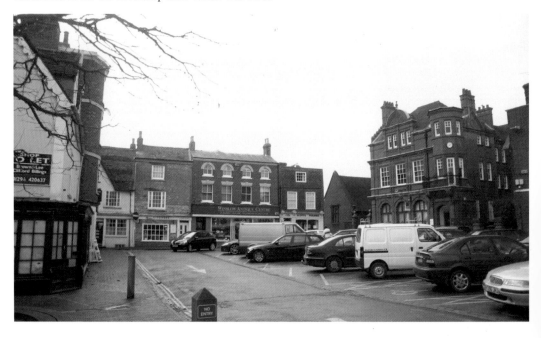

The same scene today shows some cosmetic improvements and the parking ticket machine that caused controversy. The bank, on the right, has lost its spire and the hunt is banned.

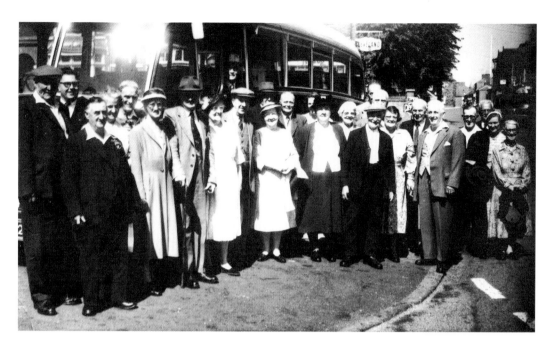

Bill French stands second left with his maroon Bedford SB coach and a group of mystery trippers in 1958. He has parked the pride of the Winslow Coach fleet on the square. Ted Leaf's filling station is just visible in the background. Driver Reg Brough alarmed boss, Meg French, when he wedged this new coach in the narrow entrance to their Sheep Street depot in 1960 – it was longer than their others. (Norman Saving)

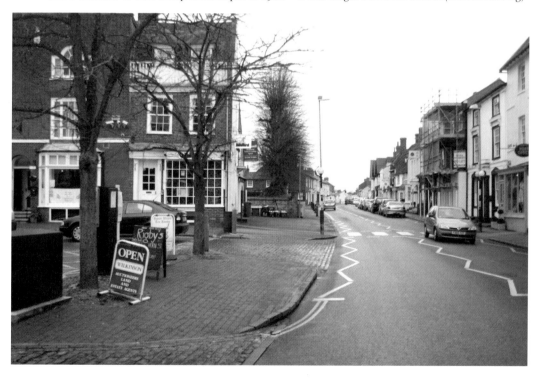

The same location in 2009. The filling station became an estate agents, which has temporarily closed.

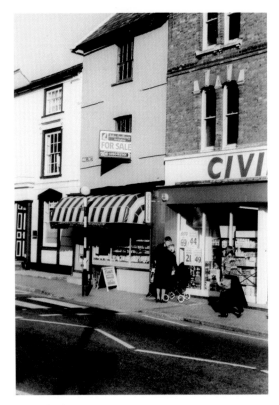

Civil's supermarket – originally Hawley's – is on the right in 1985. The late Maurice Newman's delicatessen is on the left. Maurice's dad, Bill, started the business and was the first to bring frozen food to town. Bill also had the distinction of being bombed by the US airforce at his Granborough home two miles away. The explosion demolished his house and Ford T type van. He and his wife took shelter under the inglenook fireplace. Only a sweet tin stopped a beam from crushing them.

The location is little changed. Newman's is now a dress shop and One Stop have taken over the supermarket.

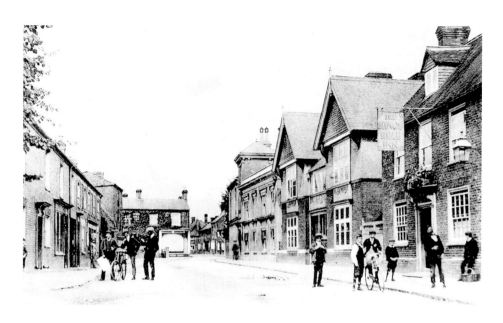

Winslow High Street *c*.1912. The large gable end building dominates the scene. Called 'The Firs' it served as a World War One convalescent hospital and the Rural District Council offices. The Council was abolished in 1974, with all powers moving to the remote Aylesbury Vale District Council (AVDC). AVDC has been criticised for focusing too much of council taxpayers money on the ethnically diverse and rapidly expanding Aylesbury. Winslow has two representatives on AVDC.

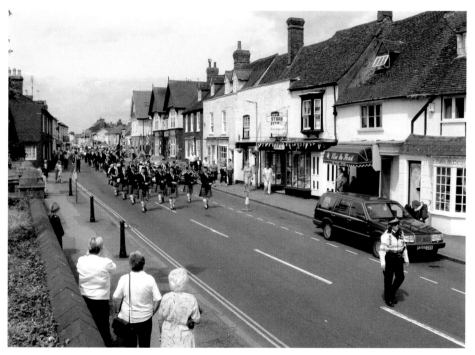

Roughly the same outlook today, this picture is taken from the old church burial ground during D-Day anniversary celebrations in 2004. The historic building on the far side of The Firs was part of the old council offices. It was demolished and replaced with modern flats in 2002.

The Windmill public House in Middle High Street, 1960. The Wilson family then ran the pub and there was still a blacksmith working in the back yard.

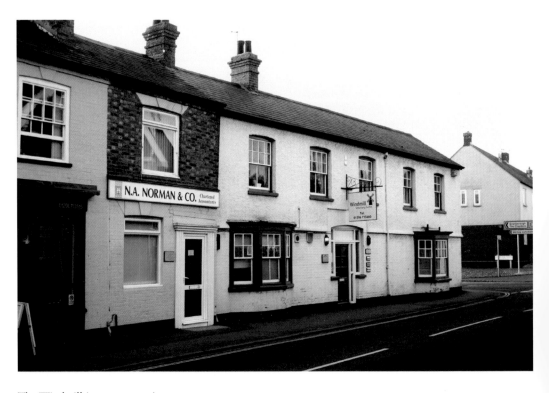

The Windmill is now a veterinary surgery.

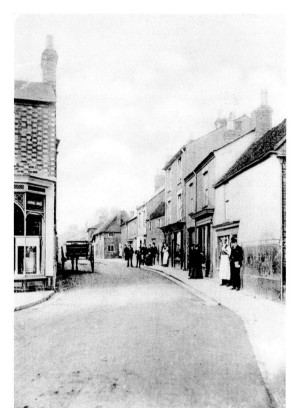

The scene at the junction of middle High Street and Vicarage Road (left) and what became Greyhound Lane on the right, c.1913. The road was very narrow at this point because of the furniture shop (which became the electricity shop and showrooms in 1936) jutting out on the right. A line of cottages next to this building made the entrance to Greyhound Lane very narrow.

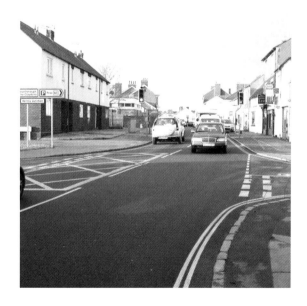

The scene today is much altered. The large house and former builders yard behind the furniture shop has been redeveloped as high density and expensive housing and a microwave transmitter has been placed on the fire station behind them – with no thought to health concerns. Greyhound Lane has been built along the line of the old backyard entranceway. It leads to a car park and recently built flats, which have been built in Gibbard's old yard.

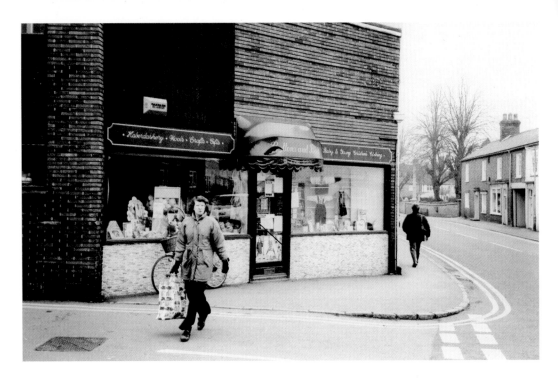

Looking across Greyhound Lane in the opposite and southerly direction. The shop was originally built for Chowles jewellers, which was long established in town and moved here in 1959. The shop has various occupants until demolition in 2002.

Looking at the same spot in 2009, we see the corner of a block of new flats, built on the old council office site, offices which housed the town's first public library, and where veteran librarian Ruth Hall made her début.

Looking north from mid High Street outside R.J. Saunders cycle, electrical, and TV shop in 1965. The shop immediately right is Lambourne's fishmongers and fish and chip shop. The tall man is Charles Cripps, a bricklayer. He has just left the post office and is approaching the site that would become the new fire station – on his right. The sheds would eventually be demolished for the fire station and new telephone exchange. The original National School was on this site.

By 2009, new housing and the cuboid telephone exchange have tidied the eastern side up. The gable end of the now closed post office catches the sunlight and a pelican crossing has been installed to make it possible to cross the road. The building line on the right is much the same and there is still a fish and chip shop.

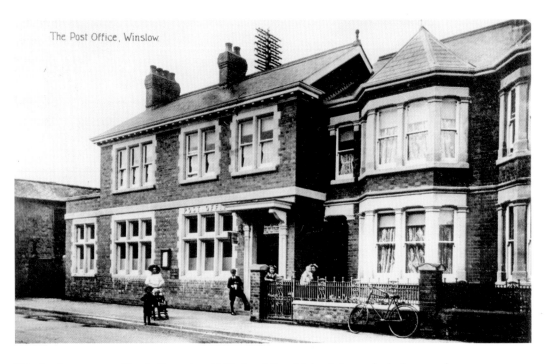

The Post Office, Winslow.

Winslow's new post office, built on the old National Boys' School site, and telephone exchange, soon after opening in 1912. The house next door was for the postmistress. Next door was the town gas works – now the undertakers. The base of the old circular gasometer is still in the cellar.

The post office closed in January 1990 and is now empty. The postmaster's house next door is an estate agents.

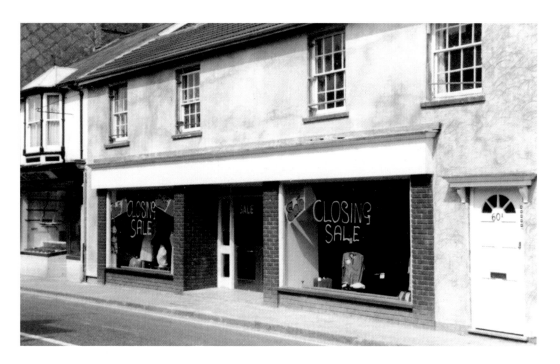

This building was Woodman's drapery store. Woodman called his shop Manchester House, while his friend and rival Bobby Fulks called his premises London House. They used to play tennis together and were both bachelors. This picture marks the closing down sale in 1982.

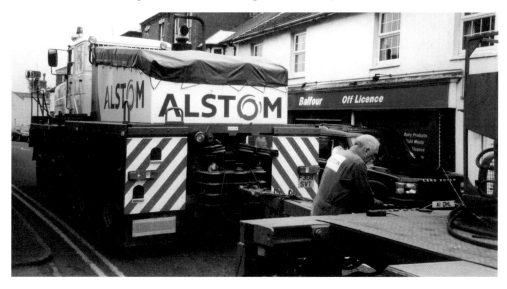

This image of the old Woodman's shop shows its conversion to groceries, seen here in 2000. It is now the Co-op. It was taken as a heavy haulage lorry was returning north, having delivered a new transformer to east Claydon sub power station. The power station opened in mid 1960s, to cope with increased power needs. The first transformers were taken via Horn Street until one got stuck up against the George Pub on Bell Corner. Then the decision was made to widen the entrance to Vicarage Road by demolishing the old electricity shop and cottages. However it is still a tight squeeze for a huge truck, with a long trailer and two other units pushing it.

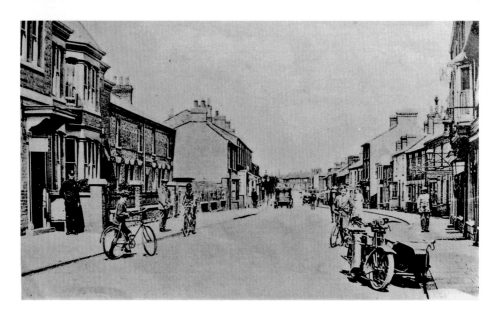

Looking north from just under the post office porch reveals upper High Street in the 1920s. A motor cycle and sidecar was the poorer man's car and quite novel. It was across this piece of sky, on 7 August 1943, that a Wellington bomber flew east, back to RAF Little Horwood after a training flight. Streetlights were out. Thinking he was near the runway, the pilot clipped a chimney on the left of this picture and crashed into housing behind the High Street. He was approximately in line with what is now Elmfield Gate. Retired policeman John Gillett drove one of the RAF fire tenders. Another witness recalls the fire setting off live ammunition. Only one crewmember survived.

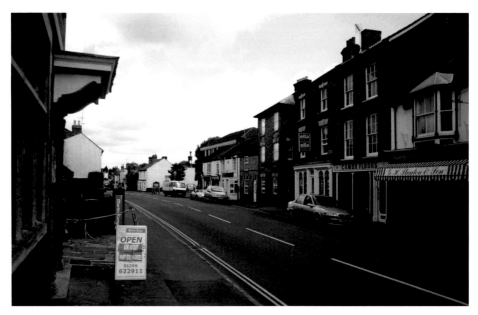

The town post office in 1907. It housed the original manual telephone exchange which remained in use until a temporary automatic exchange was built on land left derelict since the 1933 Great Fire, next to Cantell's Stores.

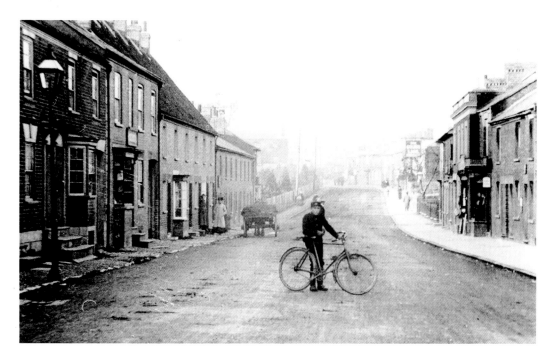

Telegraph Boy Ralph Langley with bicycle in 1908. Telegrams were in their heyday and Ralph and colleague Tom Cripps carried them for miles. Winslow Union Workhouse looms up over the railings in the background and stately telegraph poles signal progress. Even greater change was looming. At the time this photo was taken, Germany was heightening tensions by backing the Boers against Britain. Langley and Cripps would soon be swelling the ranks of the local regiment in the Great War of 1914-18.

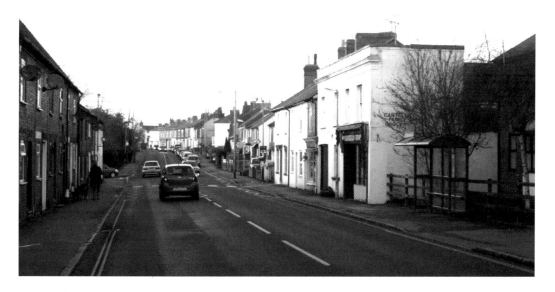

Looking from the same place today, we see that the workhouse has gone, but the familiar landmark of Cantell's Stores is still there. The gap in the houses marks the site of the Great Fire of Winslow on 13 December 1933. The Frenchs owned the shop then and their son threw out hot ashes which set fire to a fence and then the timber yard behind Gibbard's shop.

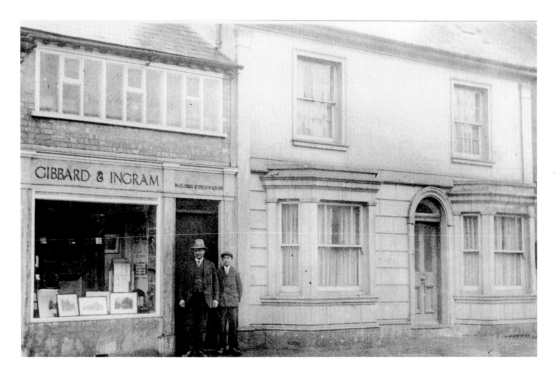

Two of the properties destroyed in by the Great Fire. Photographed in the early 1920s, Mr Gibbard is standing with his employee, young Benny Kerrison – the latter becoming volunteer Fire Chief and spending his whole working life with Gibbard and Ingram builders.

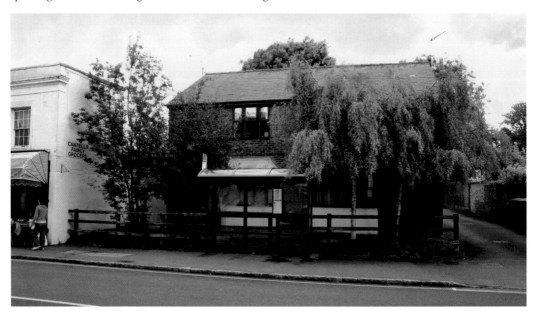

Gibbard & Ingrams' and the house next door were destroyed by the Great Fire of December 1933. The grocer's son from Cantell's stores threw hot ashes against a wooden fence. It caught fire, the blaze spreading to the builder's yard and neighbouring houses. A gap was left until a temporary automatic telephone exchange was put here in 1966. These flats were built in the late 1980s.

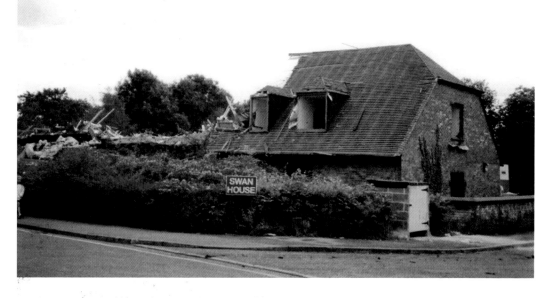

Swan House old people's home during demolition in 2002. European initiatives dictated that care of the elderly should include everyone having an *en suite*. The building was on the site of the old workhouse, which became a sort of mental hospital after World War Two.

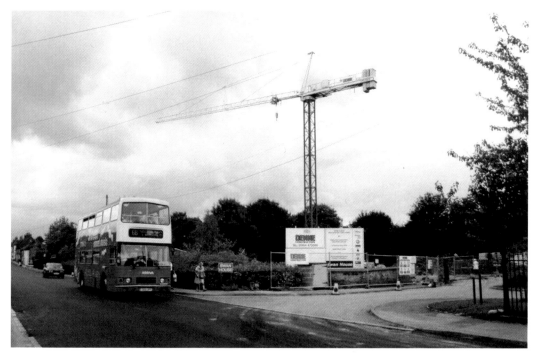

Swan House site is clear for redevelopment. By this time care of the elderly had been privatised and many had to give up their homes to receive it. A tower crane is a rare sight in Winslow.

This shop, pictured in 1982, was once the premises of Dobb's cobblers. Mr Dobbs sat in the bay window mending shoes. His only daughter met a GI, Layle Kellogg, while working at the post office in Bletchley during the war. It was a great wrench for him and his wife to see their only child, Peggy, sail away to the United States in 1945. (Malcolm McIntyre Ure)

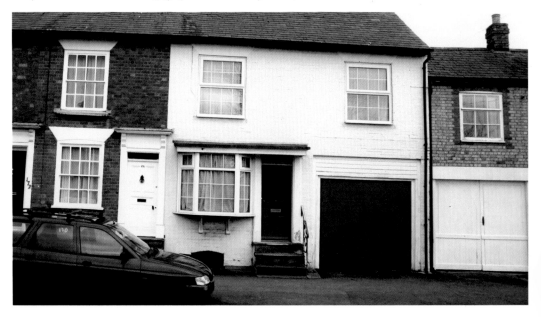

The premises are no longer used for retail.

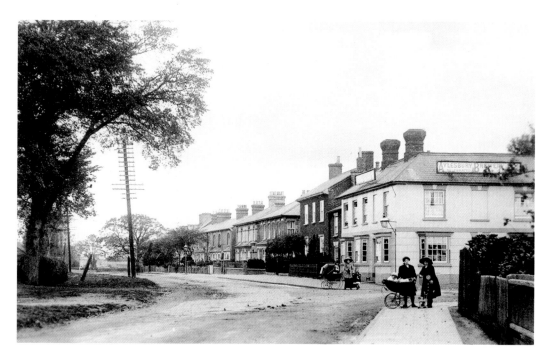

The junction of High Street, Buckingham Road and Station Road in 1912. The Swan is a distinctive landmark.

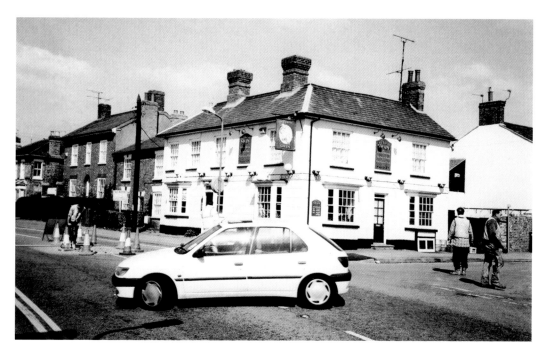

Road works were undertaken in the summer of 1996 to install a mini roundabout at the Station Road junction, as can be seen. With a busy filling station opposite, it is still a difficult place to negotiate in peak period traffic.

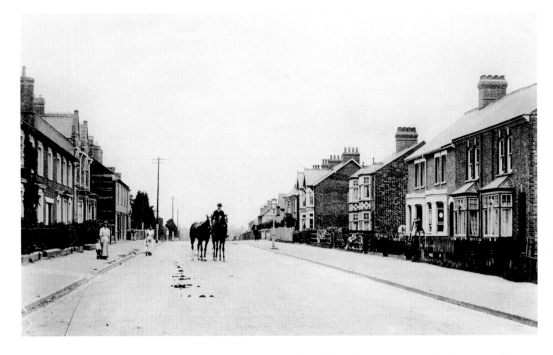

The entrance to Station Road in 1912. It takes its name from the railway station at the bottom end, which opened to passengers in 1851 and closed in 1967 – a Labour Government, not a Beeching decision – at the very moment it was going to be needed because Milton Keynes was starting development.

The scene at the top of Station Road is much the same today, except for the motor vehicles. Half way along there is now a struggling industrial estate and former council house estate leading off from the right of this road. It also connects with a private estate and Little Horwood Road – making the junction with High Street very busy – hence the roundabout.

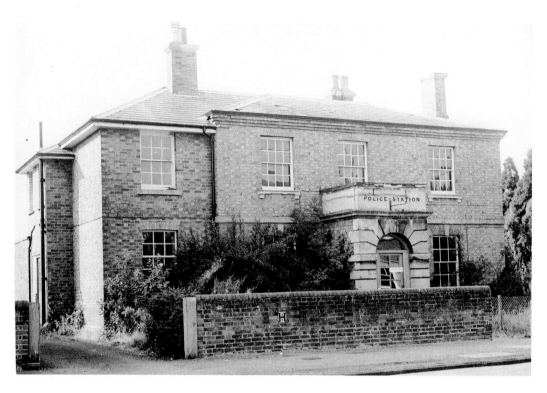

The Police Station, in Station Road. Its Victorian cells made it a popular location for filmmakers, up until closure in 1985. Winslow was a bit like *Heartbeat* in the 1950s and '60s. The station had its own sergeant and lots of policeman walking the beat, or riding around in a black Ford Prefect car. There was also an attached Magistrates Court. Captain Micklem was the legendary magistrate.

The police station was demolished after being abandoned for several years. The premises had such a large garden and orchard that there was room enough for this small housing estate, appropriately named Court House Close.

The old railway station the day before demolition in 1990. (Colin Stacey)

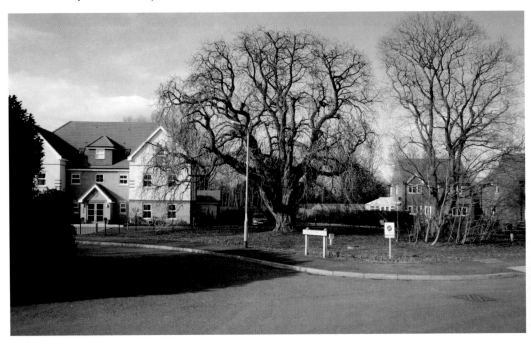

The same location in 2009 shows the new housing development, named after veteran railwayman and local signal box operator, Dennis Comerford – Comerford Way. Another railwayman and World War One sailor, Ernie Byford, has a road named after him off Vicarage Road. The Co-op had a coal delivery depot based here and the new gasworks opened, just behind where the photographer is standing, in the early 1950s.

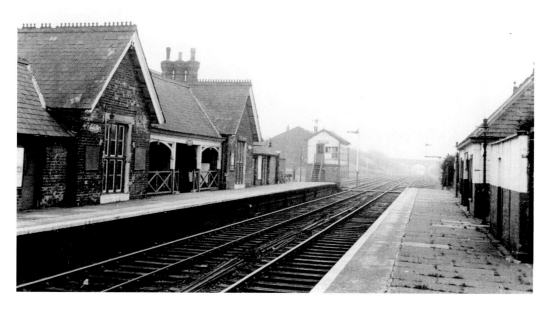

Winslow Railway Station, looking toward the Buckingham Road Bridge. Verney Junction was two miles up the line, with a branch to Buckingham and Banbury. Up until the 1930s, there was also a link to the Metropolitan line. Lord Chandos invested in the Verney junction and the London link in the expectation of a Channel tunnel. Verney never became quite the stopping off point he anticipated, but the large pub and former little hotel is still there on the green sadly the station has gone. (R.H.G. Simpson)

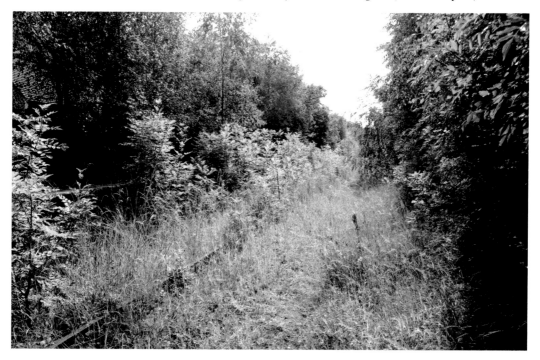

Looking west at where Winslow Station used to be, in July 2009, the scene looks a bit like the Amazon Jungle. It is buzzing with insects and wildlife in the undergrowth.

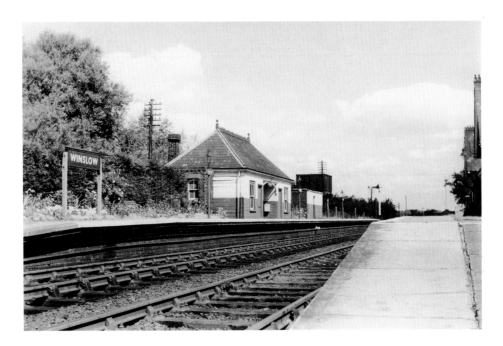

Winslow Station 1952. Under the guidance of Ernie Byford, the station gardens were a picture in summer and competed in best kept station competitions. Gayton's water tower was less than a mile along this line toward Bletchley. After her husband's death, Fanny Gayton lived in the accommodation below. One winter's morning, Dennis Comerford noticed that there was no smoke coming from her chimney. He walked up the line and found that she had drowned in a pool after falling from the water tank's steps. Many years earlier, the Gayton's had set the place alight by going out and leaving washing in front of the fire. (Dave Barrow)

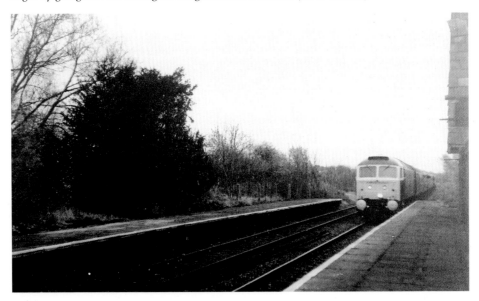

The Royal Train was housed at the old Wolverton Railway works when this picture was taken in 1985. Here it is seen approaching the derelict Winslow station platforms from the Bletchley direction. (Jamie McLernon)

Buckingham Road & Beyond

Above: This scene is north of Station Road, on the Buckingham Road side of the present mini roundabout. The picture shows the old Mill House where Ernie Byford grew up with his family. His father ran the mill. By the 1950s, it was home of ex-wartime soldier and headmaster, Norman Bevan. Bevan had moved with his senior pupils from Sheep Street school, to the new secondary modern school – in Park Road – in 1959. His colleague, Mrs Horner, lived in the bungalow just visible to the right. It is now the local Tory HQ.

Below: By 2009, the Conservative Association had obtained permission and built a small housing estate in the old mill back yard, where the mill used to stand, and which had been the headmaster's garden before becoming a car park. It was built during a period when the party were struggling for donations as the Tory Party was falling out of favour – much to do with John Major's performance as Prime Minister, along with his Chancellor, Norman Lamont.

Former council houses at the far end of Buckingham Road. Former deputy head, the late Jim Hall, lived with his family in the right hand property. Postman Cyril Freeman and his family lived on the left and had a large garden. When the Freeman's died, within a short period of time, plans were submitted to build a bungalow in the large garden. AVDC said it was not suitable for development – it is close to the railway bank.

The same scene in 2009. Within a short period of time, a builder bought the property and was allowed to build a substantial house, as can be seen in this photo.

Highfield is almost opposite the Freeman's old council house, on the other side of Buckingham Road. At the time of this picture, the field was used for sports, including tennis. It was taken in the 1930s. The girl on the left is Doris Langley – she married Ralph Langley.

Highfield was Winslow's first new housing estate development. It is seen here in 2009.

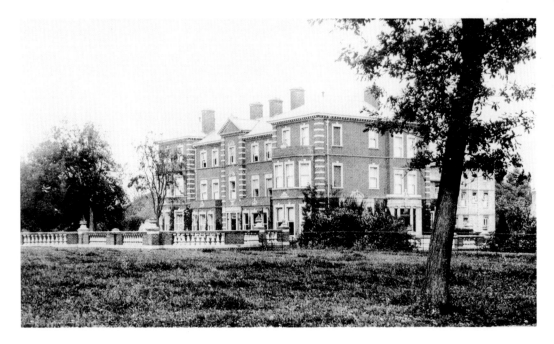

Redfield, half a mile outside Winslow on the eastern side of Buckingham Road was home to the Lambton family. H.R. Lambton bought it, with 170 acres for £17,500 in 1885. Polo was played regularly within its grounds and Lambton kept a large stable of Polo ponies and hunters. Redfield, plus 180 acres was sold to Bucks County Council for £15,500 in 1946. During World War Two the Navy requisitioned it. Bucks County Council used Redfield as an old people's home until Swan House was opened.

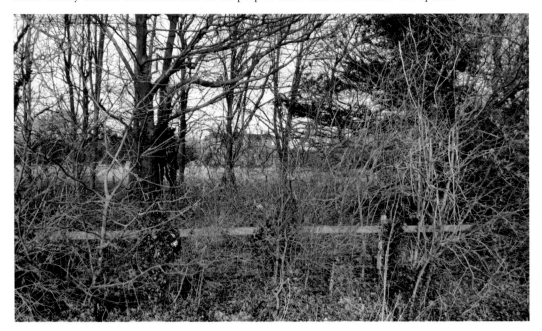

Bucks County Council abandoned their role of caring for the elderly during the Thatcher years. Redfield is now divided in flats and earned a reputation as an alternative life style commune at one time. It is seen here through trees and undergrowth, from the Buckingham Road in 2009.

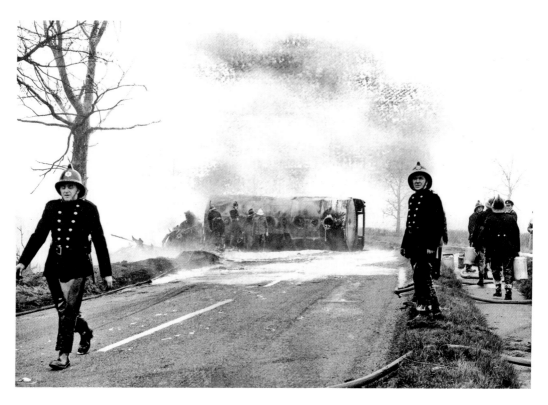

Winslow Fire Brigade attend a petrol tanker crush just past Redfield in the 1960s.

The tanker crash site in 2009. It is still an accident black spot, especially since the road became popular witht the recreational motorcyclists.

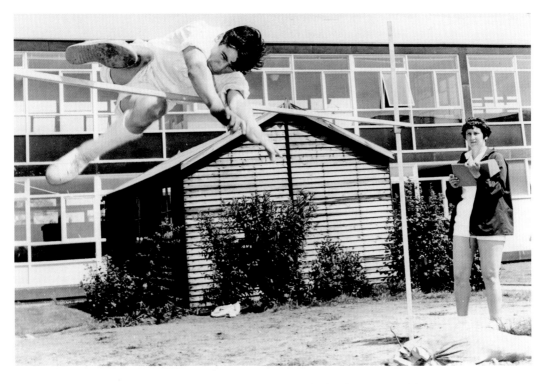

PE teacher Mrs Sizeland, at Winslow School, watches a contender for the County Athletic team in 1967.

The scene is still recognisable from the same point today.

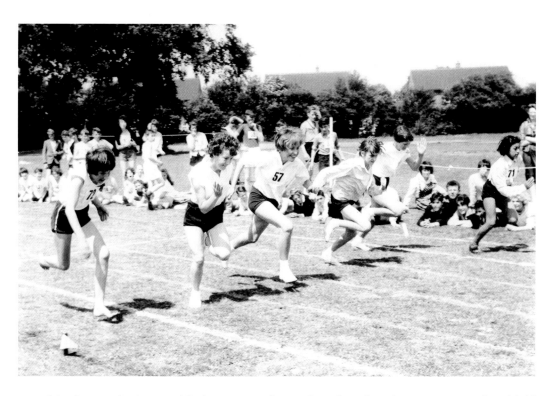

School sports day in 1965. The boys seem to be watching the girls with great interest and Highfield rooftops are just visible over the hedge.

The hedge between the old school field has gone – too much maintenance I suspect. An all weather games pitch has been constructed to the left.

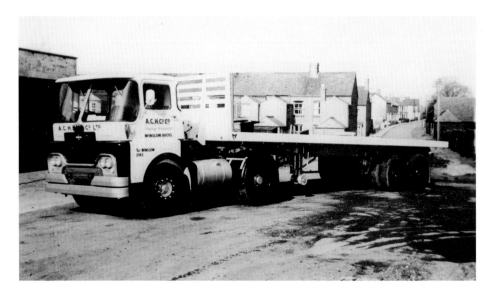

Exiting the school field by the front gate and walking a short way along Avenue Road leads to Park North and South. When this picture was taken, there was no Park Road South. It was just a track that led to the back ways into various high street properties. What is now known as park Road North is visible in the background. When this picture was taken in 1967, it was taken over by ACH Winslow Haulage. Founder Les Fowler was a policeman who used to spend spare time travelling with a haulier friend. He liked it so much, he quit the police and bought a lorry. The firm outgrew Winslow. After various moves, ACH settled in Aylesbury, where they were taken over by Norbert Dentressangle.

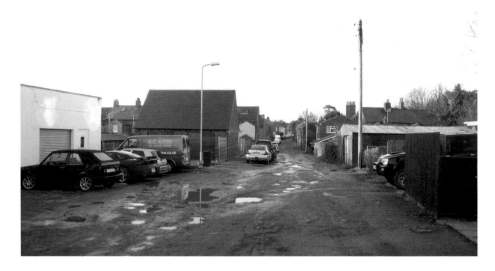

There are still workshops in the location today. However, a number of new houses have been built and the space is now officially Park Road South. There used to be a gap in the hedge behind the photographer, named 'Badger's Gap' after a man nicknamed 'Badger Young.' He got very cross when anyone passed the back of his high street home as a short cut from Vicarage Road to Park Road. This was a challenge as it was a short cut for schoolboys and to Norden House Surgery. Park Road in the background was nicknamed 'Little Moscow' because devout Labour supporters, the Langley brothers lived there with their families.

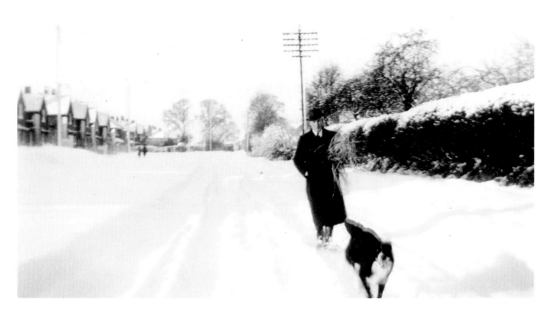

Verney Road 1963, Reg Saunders is walking his dog through deep snow. The early post war council housing is just visible.

As can be easily seen, a lot of new house building has taken place since the 1960s, opposite the council houses.

Stocks ran their dairy business from here, with pastureland behind. It became an old people's home, run by ex-nurse Gwen Walker. The land behind was given over to development in the 1990s after much protest.

The site has made way for luxury flats by 2009.

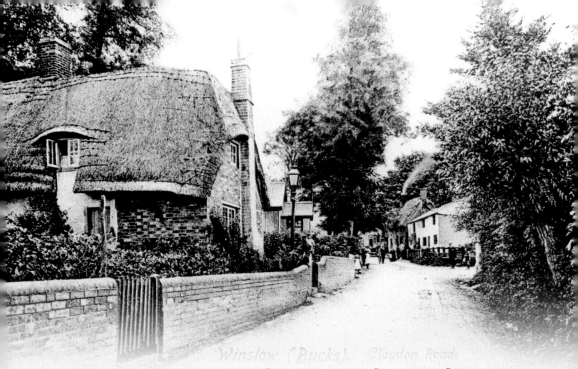

Winslow (Bucks). Claydon Road

Granborough Road and Horn Street

Above: This is the entrance to Winslow via the Granborough and Claydon Roads. The road leads up to Horn Street and its junction with Burley's Road and Western Lane. The image is early twentieth century and The Boot pub is just visible on the right.

Below: This scene is a little closer to The Boot pub, which had been renamed The Devil in the Boot. This picture was taken just before closure in the mid-1990s.

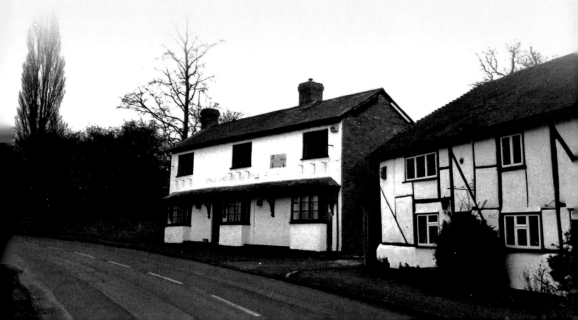

This image was made *c*.1905, before Burley's Road. The last properties at this end of Horn Street are just visible. Granborough Road leads up from the right.

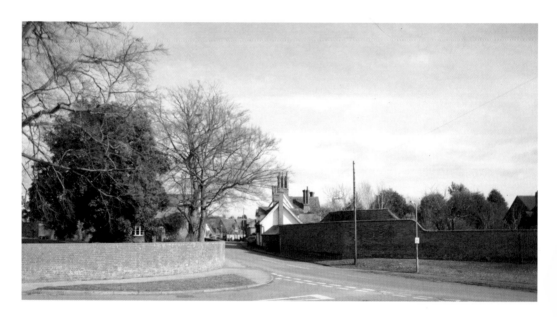

The scene looks little different today, but Burley's Road – named after Rural District Cllr Burley and built in the 1950s for council housing, is in place, connecting Vicarage, Verney and Granborough Roads. It is a popular cut through. The wall belonged to the long demolished Western House, along with the substantial stable buildings and flats that replaced it and were also demolished. Executive housing was put in its place and named Bevan Court. One well-to-do and irate occupant of the new estate wrote in protest to the Town Council at the naming of his new address. This is a Tory safe seat and he was outraged to think that his home was being associated with the Labour Minister who created the National Health Service just after World War Two – given the current state of the NHS I can hardly blame him.

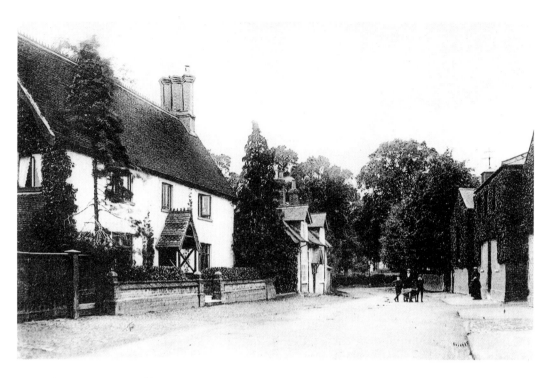

This *c.*1906 image of lower Horn Street looks very serene and the properties are substantial.

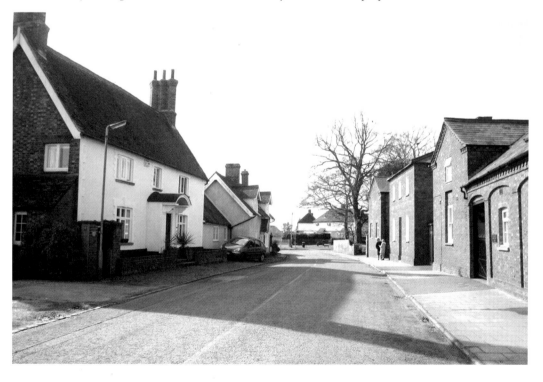

The same site today looks remarkably similar, but the veterinary surgery that occupied the red brick buildings closest to the photographer have been turned into expensive mews homes.

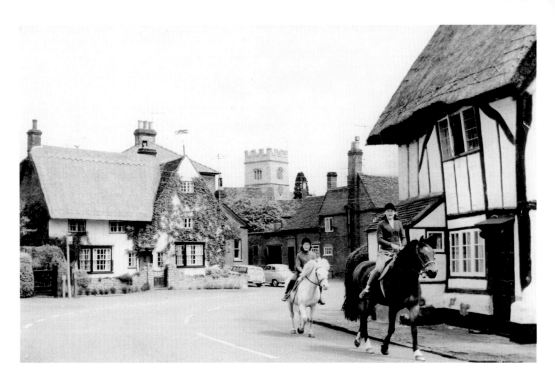

A view of Plough Cottage on the left and a couple of young riders under the afternoon sun, make this a delightful snapshot of early 1960s innocence. The Plough was, as the name suggests, a pub and home to Thomas Cripps builders at the turn of the nineteenth century.

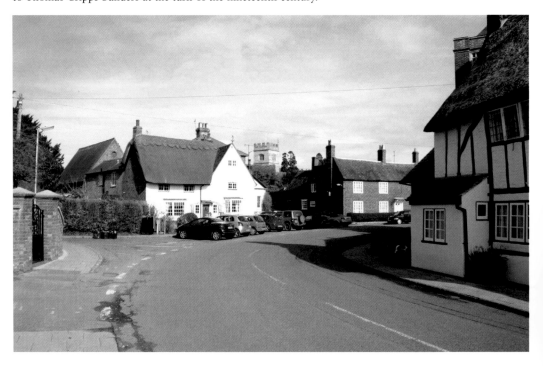

The same scene today is little changed, except for some cars and Plough Cottage is no longer thatched.

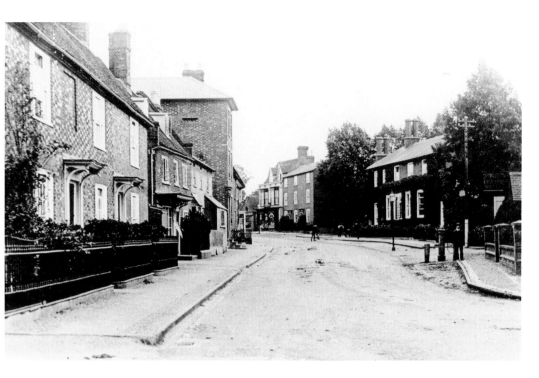

The Congregational Church c 1912. The Crooked Billett is in the centre of the first three houses.

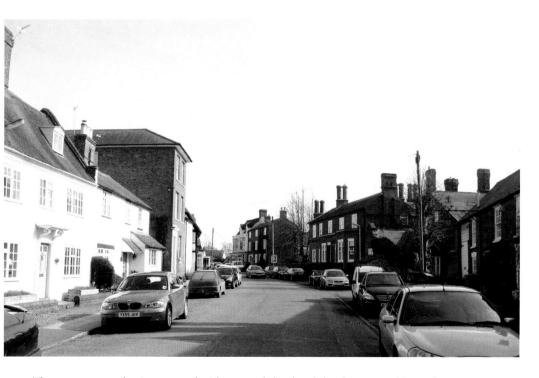

The same scene today is congested with cars and the church has been turned into a house.

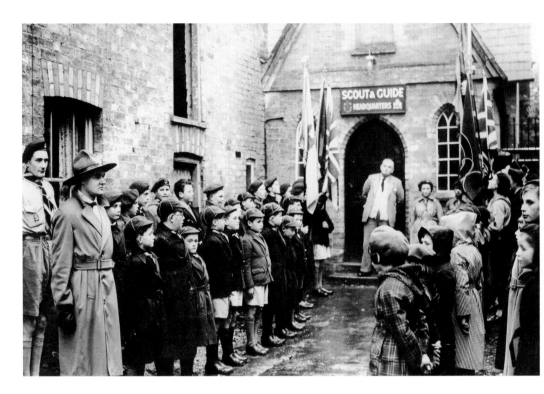

The tiny Church Walk, to the right of the previous image, leads to the Scout Hut, seen here at the early 1950s opening ceremony.

The Scouts now have a nice new building on the sports field, but the hut is still in use here, in 2009, for the Brownies.

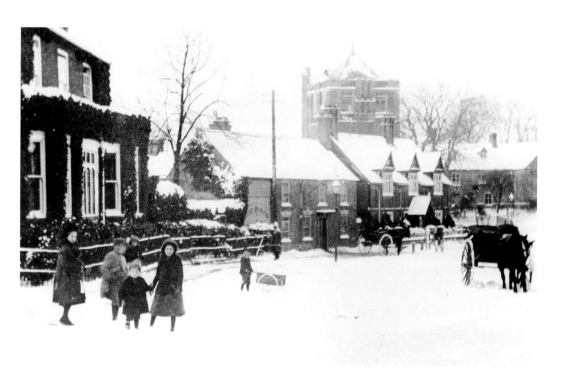

We are now approaching the top of Horn Street and facing the old Fire Station, which was moved to the High Street in 1960. The building then became the town's second library, until a new one opened on the old Secondary School site when the school closed. Illing's grocery shop is visible right. The Illings were farmers and prominent in local affairs. Grace the blacksmith's old premises is on the far left. This picture was taken *c.*1905.

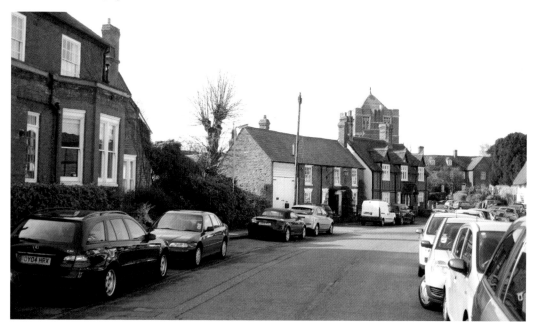

Cars dominate the location today. Illing's shop is now a trendy restaurant.

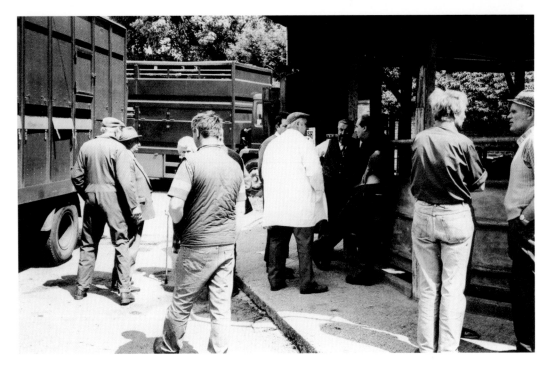

Farmers meet for the first time after the foot and mouth outbreak in the late 1990s, at Wigley's Winslow Cattle Market. Euro-sceptic George French, brother of Bill, stands far left.

Controversial redevelopment of the last livestock market in North Bucks is underway in this 2009 shot of the same cattle market site. Home Close is visible in the background.

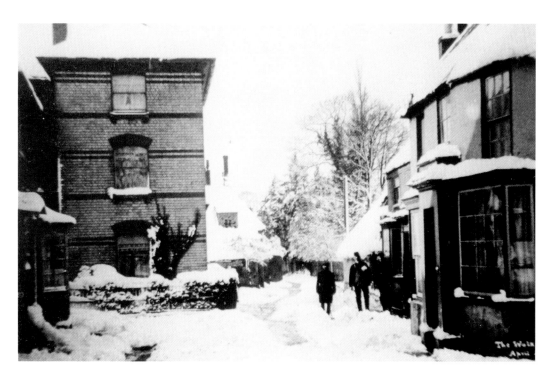

This is the entrance to The Walk, with the cattle market just to the left. The Walk leads into a footpath and onto the old Boot pub and Granborough Road. In this *c.*1912 scene, a postman is making deliveries in the snow.

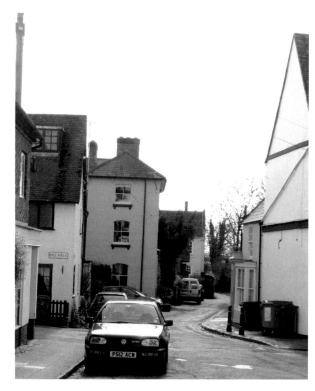

The same scene today is little changed except for the cars.

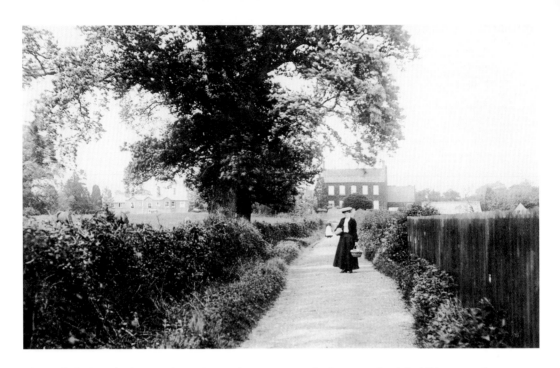

The Walk, looking back toward Winslow and Sunny Lawn, the house to the right. This pretty picture was taken c.1908.

The Walk's hedgerow is so overgrown that this picture is taken a little closer to Sunny Lawn. The house is much unchanged and is home to QC Desmond Fennell who chaired the King's Cross tube station disaster inquiry.

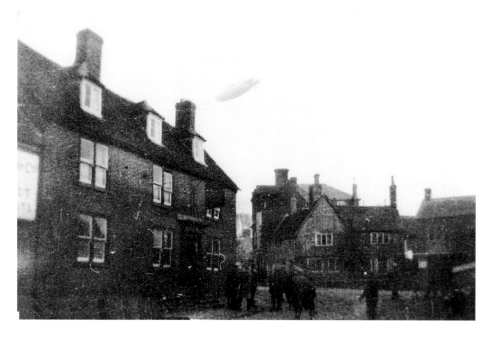

Coming out of the Walk, we face The Bull pub. In this image we are back in 1929. The doomed airship *R101* is overhead on a trial flight from Cardington in Bedfordshire. The ship's captain was aware of the airship's leaky gasbags and poor performance – it lacked what was called 'disposable lift'. He wrote to his wife saying that he had to do his duty. The ship was the largest object ever to fly. It crashed near Paris, killing all but eight of those on board in a terrible fire.

The same view, a clear sky and the year is 2009. Airships have occasionally flown over Winslow from the factory in Cardington that has been trying to safely revive the concept.

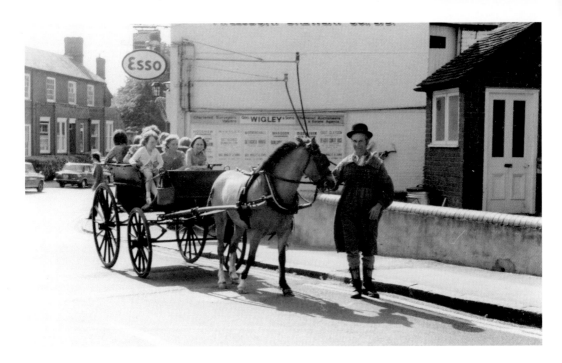

With The Bull in the background, Mr Dancer leads his pony and trap full of happy youngsters on a Winslow Show jaunt around town in the 1960s. Bill French's petrol pumps and taxi station are in the background as we prepare to leave Horn Street.

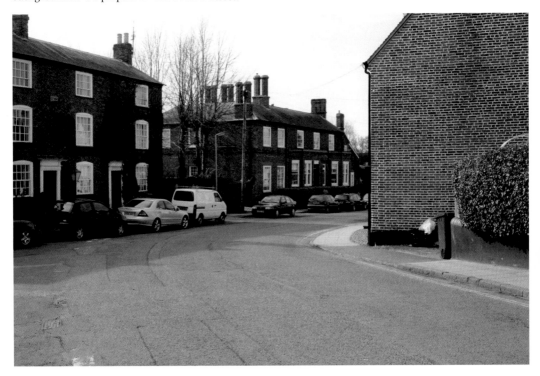

By 2009, the old petrol pumps, French's taxis and Mr Dancer's pony trap are long gone.

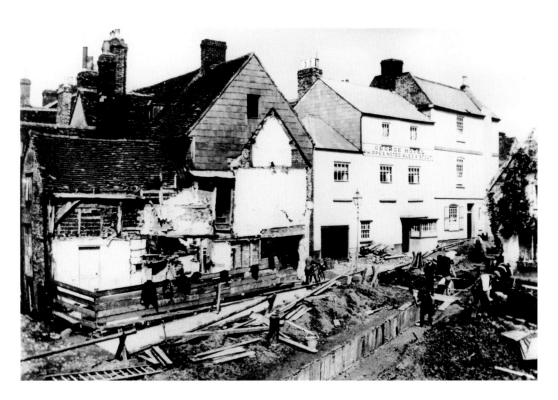

Modern sewers, leading down to treatment works near Granborough Brook are being laid in Horn Street in this 1903 picture taken near The George pub at the narrow part, where Horn street joins the market Square.

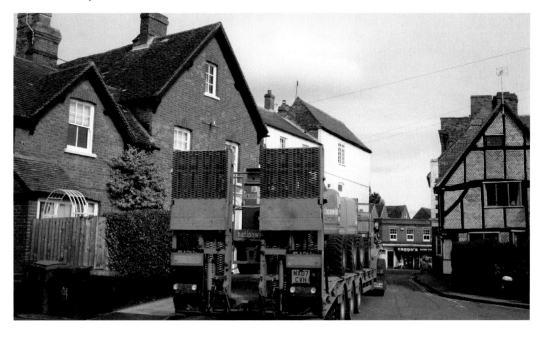

From the same spot today, we see even very large vehicles struggle through this bottleneck toward the Bell Corner.

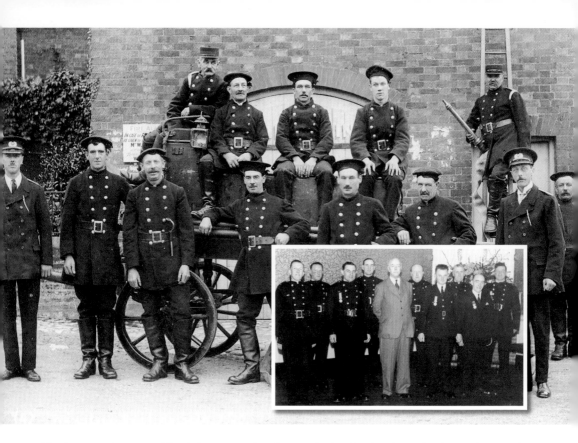

The first sign of organised fire fighting was a handcart parked in the church porch. This appliance only served blazes covered by the insurance mark. Even then communication was so bad that the fire could be well advanced before the brigade assembled. Uniformed crew in the early twentieth century dated from the 1870s, they carried little water on board and relied on the town's 169 wells and pumps. In early days, horses were commandeered from passing tradesmen.

In 1926, the Brigade became part of the National Fire Brigade Association. Inspired by competitions with other brigades, Winslow purchased a second Gem Steam fire engine from Bicester RDC, for £46 18 shillings. Captain Lambton chipped in by donating his old Daimler to tow it. The combination came in very handy for the Great Fire in 1933. Fred Illing was the captain. He is pictured here with the local crew in the 1950s, by which time Winslow's fire-fighters had been through a world war as part of the National Fire Brigade and had been taken over by Bucks County Council as part time retained firemen. Their homes were fitted with bells to summon them in time of emergency. If they were out at work in the fields, like farmer Derek Illing (pictured far right) or serving in local shops, they would hear the fire station siren sound, as if war had been declared. Then it was time to hop in the car, or more commonly to jump on their bicycles and head for the station. In the early County days, they still used an open top fire engine and men hung on to the side. Then they got an old wartime Ford tender. In the 1960s, they enjoyed real luxury with a Commer, fitted with a crew cab. Its call sign was HB133 over the new-fangled radio. They also got a new fire station in the High Street complete with a games and a rest room. As post-war society advanced and the town and surrounding area expanded, the demand for ever more sophisticated equipment was ever expanding.

The old Vicarage *c*.1912. This was an expensive place to heat and vicars were not well paid. Rev Arthur Barnes shocked the local community when he was reported in the local press in the early 1960s. He had been caught removing coal from a bunker placed by the railway line just out of Winslow. The bunkers were there as back up fuel for passing steam engines. Rev Barnes said he thought it had fallen off of the engines' tenders.

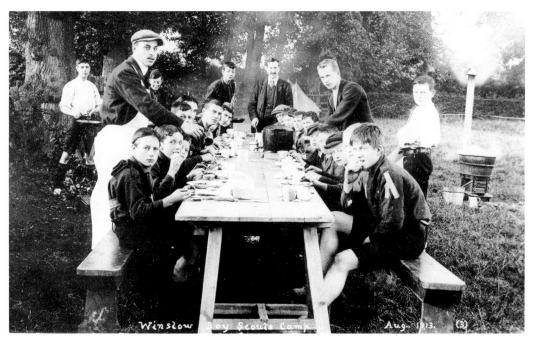

Scouts enjoy camp in Elmfields in August 1913. One of them was young Ralph Langley. Just as well he was suited to camping because he would soon be a soldier, helping to fight World War One.

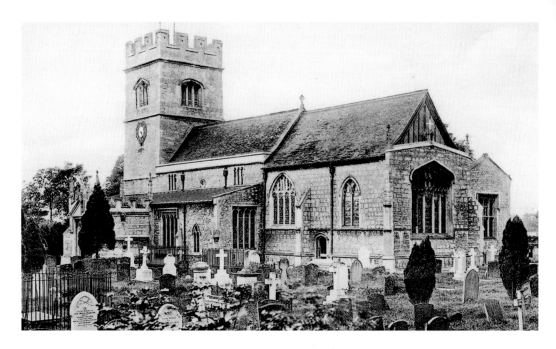

St Laurence Church *c*.1910. Before World War Two, religion was the glue that held not just Winslow, but the whole nation together. Conformity in everything was the watchword in those days. Even Rev Benjamin Keach got into trouble for preaching a slightly different version of Christianity in his chapel near the old cattle market in 1664. He published a booklet with child rearing in mind and was put in the stocks in Aylesbury. Another seventeenth century Winslow troublemaker was Sarah Fyge, who lived with her parents at Brook Hall in Sheep Street – the original manor house. She wrote, among other things, the worrying lines: 'Poor womankind is in every state a slave.' But as Winslow's Rev Denny wrote, early in the twentieth century: 'All things are bounded and temporal.'

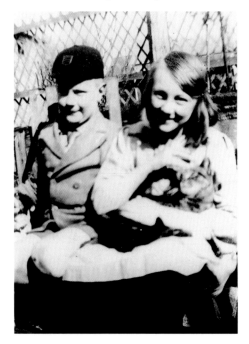

Jack Hone was estate manager for McCorquodales. He lived at 15 Sheep Street when he took this photo of his children in the early 1930s. It is an image of childhood bliss, which brings to life the words, of William Turnham about the delightful air of Winslow. It is no wonder that these days newcomers pay a high price to live here and many locals cannot afford to stay.

Keach's Chapel has been preserved. This picture was taken a few years ago when members of the town council were concerned about the effects of converting the former Midgeley's ironmonger's store into a bungalow right on its boundary. They felt that it would destroy the chapel's remote historic charm and overwhelm its tiny churchyard.

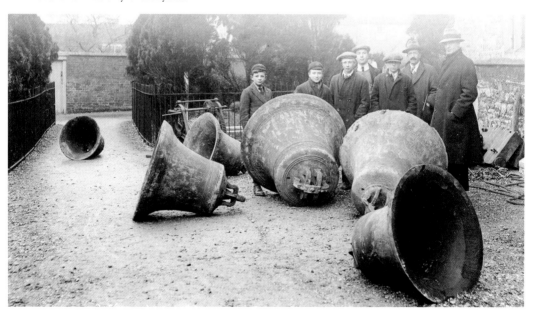

Winslow's church bells have only recently been overhauled. They take a lot of wear and tear. This picture shows them going for reconditioning in January 1929. Church bells were to be used as a mass warning signal in the event of a German invasion during World War Two.

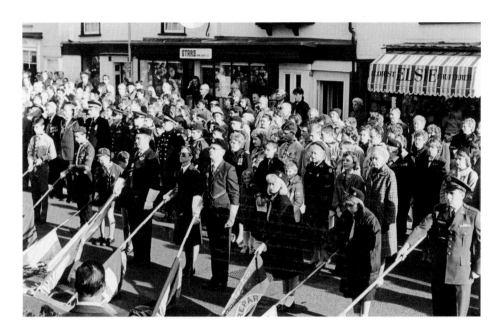

Remembrance is an important process if we are to make an informed choice about the way forward. It is also a way of honouring those, like Jesus, who lay down their lives for the benefit of future generations. But the modern way of life, greed and political corruption makes me wonder whether such ceremonies make their point. This picture was taken in 1990.

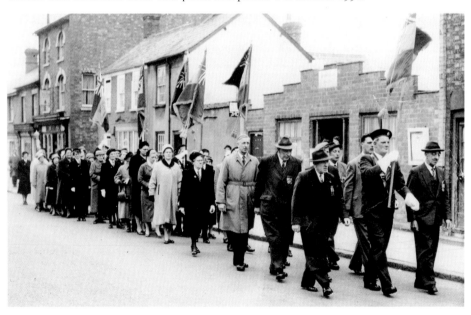

Looking back to 1955, it all seems so far away. Here we see members of Winslow Royal British Legion marching past their HQ in Winslow High Street. There are few left who will remember these old faces. A regular soldier, from the British Indian Army, carries the standard at the head of the parade. Hallrohan's TV, radio and record shop stands higher than the rest, next to other little properties. The whole lot was demolished in the early 1970s to make way for Elmfield Gate's access road to expanding housing development and a new public hall.

Winslow retains many beauty spots around its boundaries, as we see here at Furze Lane (Featherbed or Back Lane to old locals), on the western edge of town. This charming view in 2009 is set to become an access road to yet more housing and industrial development. In the distance, a small hump back bridge is visible rising over the old Oxford-Cambridge railway line. At the moment the lane leads to the new burial ground that is almost full, although having only been opened in the early 1990s.

As the pre-war generation disappears, so do old skills like this one being demonstrated by the late Ethel Stokes at Christmas 2000. She and her husband Bill, came to work for Lord and Lady Latham. From a male point of view, women have always been different. But they were very much more different in the old days.

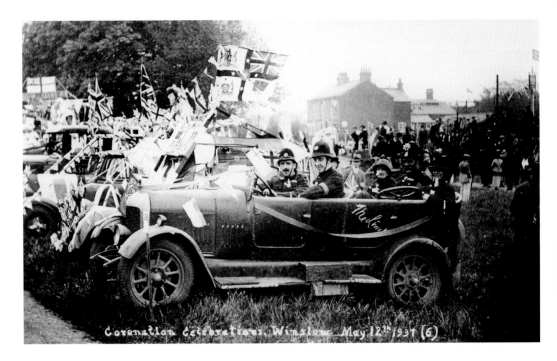

There has always been a lot of fun and games in Winslow – some of it unprintable. This picture takes us back to the Coronation celebrations in 1935, on the railway station green, next to the famous Cappodalacian Maple tree – now preserved among the new housing. The tall man dressed up as a policeman in the front car passenger seat, is William Charles Cripps, a member of the renowned local building family that married into Walker's builders.

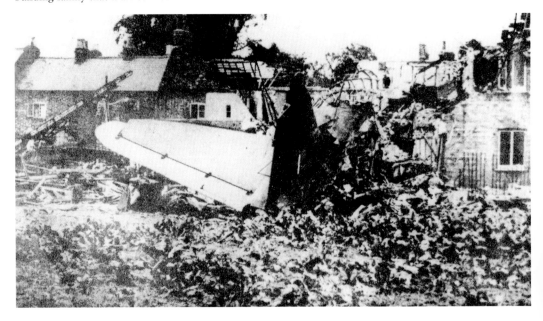

The new king, George VI had not been long on his throne when war started in 1939. In August 1943, a Wellington bomber from RAF Little Horwood crashed on houses behind the High Street, known locally as 'Monkey Alley.'

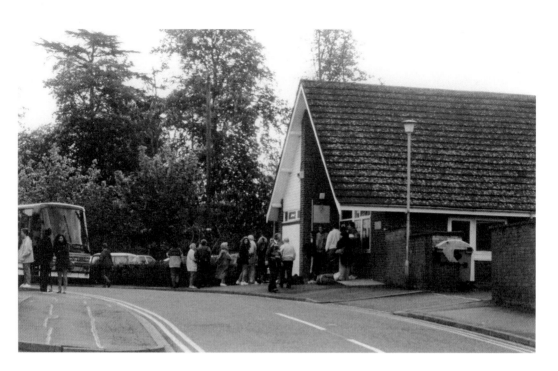

The ruined houses were never rebuilt and the land lay derelict until the access road was built into the new housing being built on McCorquodale's old estate, known as Elmfields. Redevelopment included this new home for the Royal British Legion and the public hall car park behind. Local member, Ernie Byford, was one who campaigned to get the British Legion the Royal Warrant in honour of the desperate and forgotten heroes of World War One's carnage. Many ex-soldiers were reduced to tramps. This photo was taken in the late 1990s when members of Winslow's twin town Coeur La Ville were visiting.

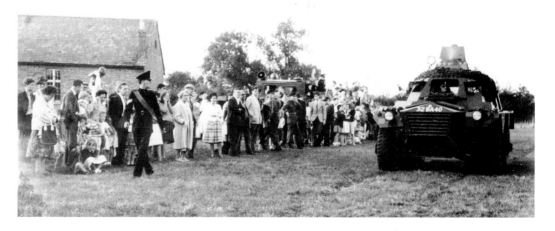

The sports field was provided for the benefit of the whole community and paid for by money from public subscription in 1947. It became home to Winslow United Football Team who played in the Vauxhall Conference League for some time. There was a part reserved for cricket and used by the local school until the new school opened in 1959. Here the field is being used for a recruiting display by the Royal Greenjackets regiment. The rear of the Methodist Chapel is just visible, here in 1960.

Today, the same location is only recognisable because the chapel has endured. A microwave telephone mast and base station has been built next to the new scout hut. The town council caused controversy when the decision was announced in the local paper in July 1996 – with the £10,000 annual rent being allocated to the football and sports club, according to the report. The base station's location raised health concerns for youngsters inside the scout hut. The hedgerow dividing the sports field from farmland has been replaced by a fence, behind which is Lowndes Way, which was built as council housing.

Controversial England cricketer Ian Botham visited the Sports Club in July 1986. At the time he was accused of smoking pot and issues were raised about his membership of the national side. He was part of an all star side playing the town team.

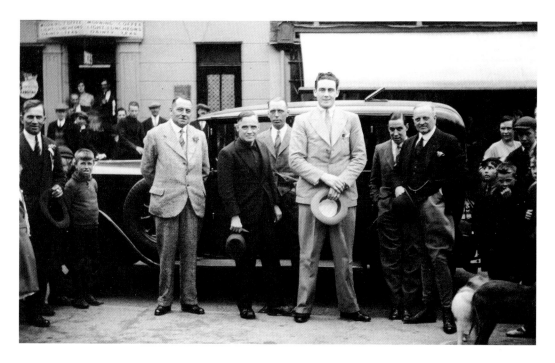

Famous people have visited the town for years. It is, after all, only fifty miles north of the capital. Boxer Jack Doyle visited in May 1938 and posed outside of what was then Doreva's café on the market square.

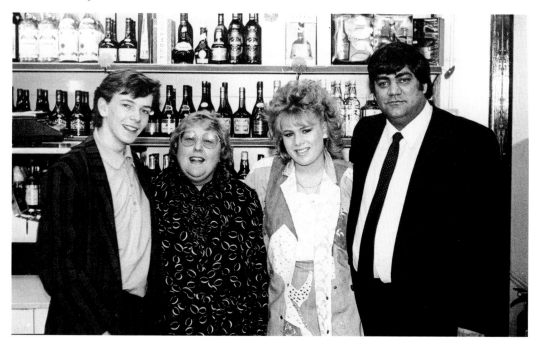

The soap *EastEnders* was an instant hit. In 1985, Zul Kaswani invited its young stars Adam Woodyatt and Letitia Dean to open his new supermarket inside the premises of the former Dudney and Johnston shop. They posed for the camera with their agent.

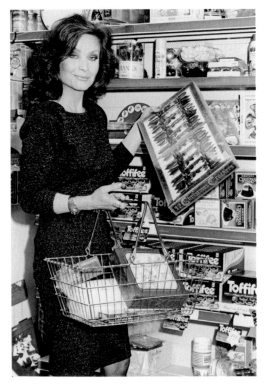

Next to help with promoting Zul's shop was curvy Kate O'Mara in December 1986, famous for appearing to bare her breasts in an episode of the odd soap, *Triangle* about a North Sea Ferry. Kate also appeared in other unusual production, playing a bitch in *The Brothers* which was about a family haulage business.

The concept of being a star is an illusion, but everyone seems to want to be one these days and they get depressed if they don't make it. Doreen Hankins (nee Tofield) was the star of Winslow Post office, being always patient and polite. She worked at the High Street office all through from the 1950s, until closure on 20 January 1990.

Tam Dayell was a Labour Party celebrity during the Thatcher and Major years. He looks a little world weary at this Labour Party meeting in St Laurence Room in 1988. He was in enemy territory, but the veteran Labour left wing MP was a match for anyone who chose to heckle him. He talked much about the Falklands War and the sinking of the *Belgrano*. His general message was to tell all that Thatcher was threatening our long term well being.

Politics are not always serious. This is not another local politician trying to sweep something under the carpet. It is District & Town (several times Mayor) Cllr Duncan Wigley cleaning up the high street Council chamber after a social gathering with members of the Anglo French Club and French dignitaries. Cllr Bob Hart is assisting him.

Sir Edward Tomkins was former ambassador to Paris. His interesting career included being taken prisoner by Rommel during World War Two after actually being sent to negotiate with him. He escaped when Italy quit the war and became a diplomat. He retired to his Winslow Hall Home, and lived there with his housekeeper at the time of this picture. He unveiled a town map, honouring Winslow's link with Coeur La Ville near what was Ted Leaf's garage on the site of the long gone Market House.

With the town full of commuters and also being a thoroughfare for more commuters from Buckingham, traffic speeding in and out of Winslow is a problem. County Councillor David Rowlands is on the case here, with two traffic cops, hiding in the doorway of 25 Sheep Street.

In the words of the old song, 'a policeman's lot is not a happy one, happy one.' Here, in 1992, they are out in force protecting farmer Colin French (now deceased) from animal rights protestors in Granborough Road, just outside of town. A helicopter was monitoring matters from overhead. Mr French was accused of cruelty to his animals and convicted – though a kinder view might have been that he simply could not cope with all the work with just one casual helper, merely doing his best to step into his late father's shoes. The animal rights people showed him no mercy.

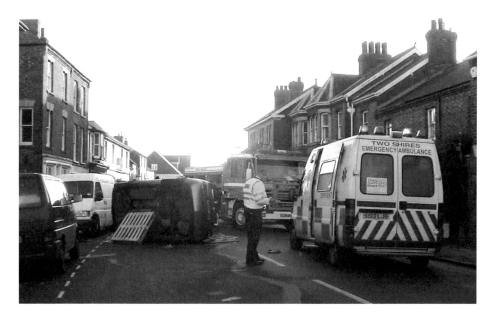

Police work is certainly varied. Here they are again in c.2003, dealing with a most unusual accident. The overturned car passed too closely to the parked Transit, which had its wheels angled into the carriageway for easy departure. The female driver's front wheels rode up the van's tyre and overturned, trapping the driver and elderly passenger.

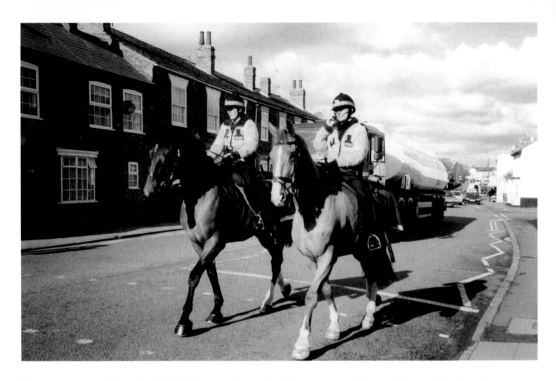

Horses were a traditional sight in Winslow, but police horses are much rarer. Presumably there is no law against using a 'phone from the saddle on this sunny day in 2003. Attractive or not, I am always reminded of the infamous 1985-6 Miners' Strike when I see police officers on horseback.

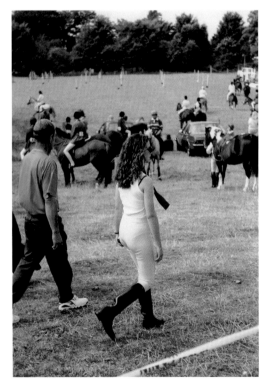

This young rider has dismounted as she struts her way through Winslow Showground in the early 1990s, at Home Close. Held on August Bank Holiday, it is the perfect place to see all sorts of fine fillies!

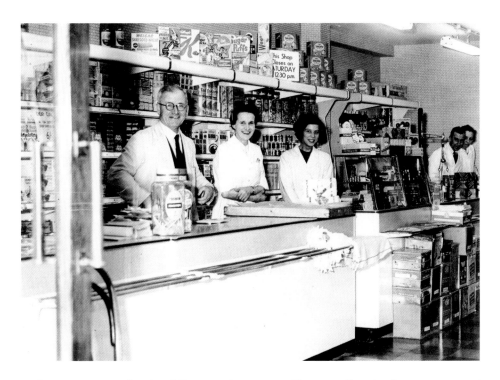

Back in 1954 it was all rather different as this picture of happy staff, under the management of Bob Holmes at the Co-op shop on Winslow Market Square. Bob's wife Doris stands next to him and one of his sons, Gordon, used to serve on the bacon counter opposite to them. Derek Rowe, far right was in the local fire brigade and always had to be ready to run when the fire siren sounded across the Winslow sky.

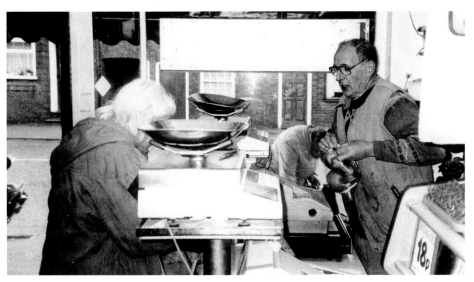

Old ways of really caring personal service were passing when this picture was taken in Upper High Street at the start of the new millennium. Shopkeeper John first came to town delivering green groceries in a lorry owned by Stephens. He came to the area as an evacuee during the war, and is seen here on the verge of retirement.

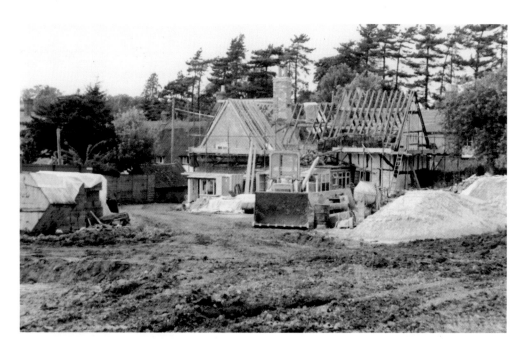

Redevelopment marches on. These two cottages were seen earlier in the Sheep Street section of the book. The old street is just in view. The scene is French's old coach yard in 1987. Four large new homes were crammed into the old coach yard. The old cottages were almost pulled right down and rebuilt, as can be seen here.

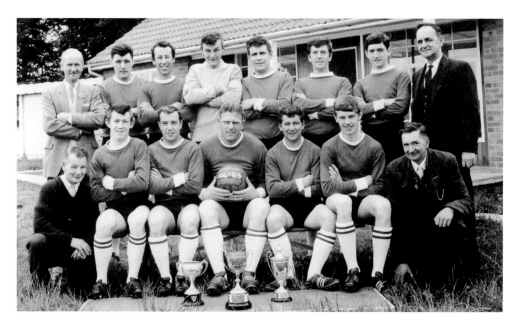

The 1960s saw the town get a new sports pavilion, seen in the background while 1964-5 cup winners pose for the camera. Bernard Warr, centre was captain. Back row, far left, is Jimmy Brown who came to town to work on the Cruise estate in Swanbourne Road. He finished his working life working on the lorries for the County Highways when the Cruise estate was sold off. Sir Richard Cruise was George V's eye specialist.

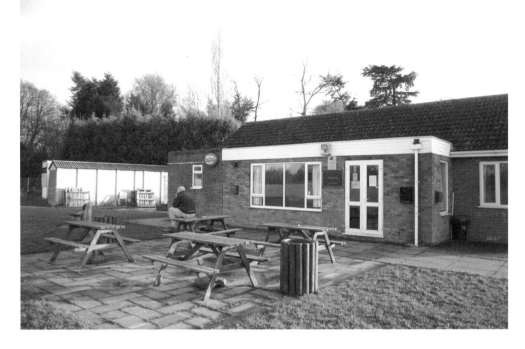

The sports club has seen a few extensions. It is a good place for cheap drinks and relaxing, as can be seen here, viewed in 2009, from the rear and looking towards Elmfield Gate.

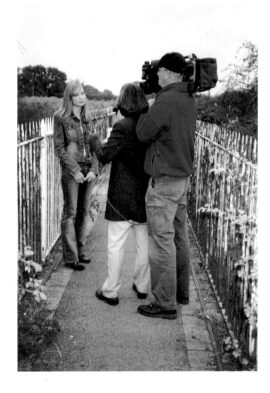

There have been complaints from young people that there is nothing to do in town. This young lady, in 2003, is telling a Central News TV reporter that she would like to see the railway line reopened so that her and her friends can more easily enjoy what Milton Keynes has to offer. The interview is taking place on the old iron bridge over the railway line.

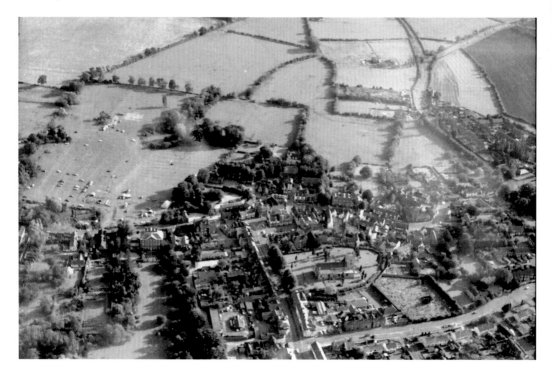

The little town, for all of its growth, still looks small and pretty, looking south here, from the air, on a lovely sunny August day in 1988. Top right, we see the road forking right from the Granborough Road at the bottom of Boot Hill, toward Claydon and Oxfordshire.

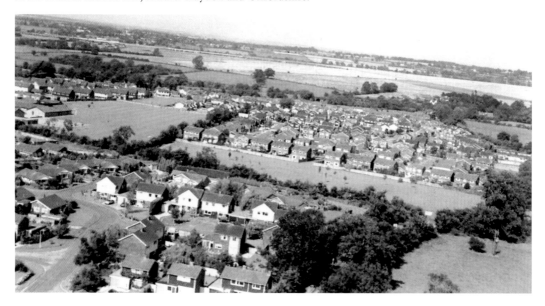

Looking in the opposite direction, we can see how houses have continued to grow further into fields beyond the spacious Elmfields development, into the more densely packed confines of Magpie Farm. The cornfields beyond once trembled to the vibrations of Wellington bombers taking off for leaflet drops across Germany. Now there is another war. It is about Greenway and whether or not up to 3,500 new homes should be built on the site of the wartime airfield.

Epilogue

Winslow entered the twentieth century very much in a rural backwater. Its people looked up and down at one another. The McCorquodales opened their printing works at Wolverton in 1878 and moved into Winslow Hall. Their roots being in what was called 'new money', they set about marrying into old – the aristocracy descended from William the Conqueror's invaders.

The first State Education Act of 1870 was all about the three Rs. It was motivated by a need to educate factory workers so that they could handle more complex machines. Winslow boys would commonly skip school to help with the harvest. Poverty was rife and keeping children in school when they could be working caused hardship. The school leaving age was only 14 when World War Two ended.

Winslow was predominantly Conservative. The 1944 Education Act enabled working class children to compete for a limited number of places at grammar school. The pass mark went up and down according to the luck and quality of any year's intake. However, old attitudes lingered on. Before the war, parents could pay for their children to go to grammar school. Passing the 11+ exam was associated in Winslow people's eyes with superiority. Failing it was the reverse.

In reality, grammar school places were calculated on the basis of what proportions of professional and manual workers were required. The 11+ sorted the children appropriately and educated them accordingly. The local population accepted the situation uncritically.

It was not until the 1960s when access to television and motor cars became more widespread that people's horizons expanded. Up until then, a trip on a Red Rover Bus to Aylesbury was quite an expedition. This would be to enjoy shops such as Woolworth's or to go to the cinema. For a brief period, Winslow had its own cinema in the Public Hall. It showed family films, like Cliff Richard's *Summer Holiday*.

Aylesbury is ten miles away. People also went there if they were unfortunate enough to need hospital. After World War Two, the much loved and appropriately named Dr Leapingwell retired. His practice was taken over by two young men who had seen war service. The senior partner was the rather brusque, and now late, Dr Peter Rudd. He had served in the Royal Navy. Working men who had seen war service were accustomed to him talking to them as if they were private soldiers or able-bodied seamen. His suave manner also enchanted a lot of ladies. To the younger generation, his old-fashioned outlook was less attractive.

In those days locals treated doctors and teachers as if they were part of the elite. Doctors were well paid, and usually came from affluent backgrounds, so they could afford houses to match their status. Dr Rudd's garden, behind Norden House was so large that it is now a housing estate. It was in this garden that he found an injured swallow.

His friend, BBC sound recording head Bill Read, lived in a converted cow shed and ran a pottery with his wife in an adjacent converted cowshed. This was in Sheep Street and was called 'Claycutters.' Bill heard Dr Rudd's story and was entranced. The story had greater effect because the doctor had such an unusually rich voice.

For a while, the good doctor had a spot on the radio. A purpose built health centre in the grounds of the adjacent former workhouse replaced Norden House. For many years the workhouse had been associated with various forms of mental health treatment. Up until the 1960s its inmates included women who had babies out of wedlock in their twenties. Unmarried mothers, often taken advantage of by the 'gentlemen' they were in service to, were treated harshly. One young Winslow woman, desperate to avoid her fate in the mental home, drowned her baby in Granborough book and was sentenced to death in 1924.

Rudd's partner, the late Dr Patrick Murphy was rather different. He was softly spoken and had an excellent bedside manner. His war service had been in the merchant navy and he had a more contemplative approach to his job, in a world that was changing faster than many locals realised.

London overspill hit Aylesbury immediately after the war, when it was declared to be an expanding town. Jerry-built, partly prefabricated housing was put up very quickly. Winslow's council housing had started between the wars and properties were substantially constructed. The 1960s saw the sale of the McCorquodale estate. The family had moved out at the start of the war, when the Hall was requisitioned by the 92nd OTU (Operational Training Unit) of the RAF. When war ended, there was a proposal to demolish it. Instead it was converted into flats. Sir Edward Tomkins was offered the whole estate for £200 an acre. He declined, buying just Winslow Hall and Home Close for £10,000.

The rest of the estate became Elmfields housing estate. The elms had gone long before, due to Dutch elm disease. The new houses were built by Gibbard & Ingram and were a snip at £5000. More aspiring and prosperous types moved in to escape the pressures and unpleasant aspects of London life. Many came with their firms who had relocated from the congested capital – firms like Nagretti & Zambra.

The 1970s saw the second phase of expansion, with the sale and development of Magpie Farm. Agriculture by this time had much reduced labour needs and the motor car was ubiquitous. Related trades like blacksmiths disappeared, though the local cattle market remained busy, along with ironmongers Donald Midgeley. Most people travelled to Aylesbury to work, or to the station to work in London. Buckingham was still fairly stagnant and Bletchley offered fewer prospects – though the railway station handled 100,000 passenger journeys per year at time of closure in 1967.

It is a sign of government's lack of foresight that they closed the Oxford-Bletchley railway link just as plans were made to build a super town, which became known as Milton Keynes. Milton Keynes was planned to accommodate 250,000 inhabitants over a thirty year period. The plan, with implementation headed up by Lord 'Jock' Campbell was intended to house working people. The surrounding countryside was also an ideal environment for their managers and other professionals, attracted away from old-fashioned urban areas. Financial pressures necessitated the town being built on the cheap and around the existing centres of Bletchley, Wolverton, Milton Keynes and Newport Pagnell, rather than the scratch built super town designed by Fred Pooley.

Over time, Milton Keynes had a huge impact on Winslow. This had more to do with consumerism than employment. The effects of mass media and motor car travel were altering outlooks. Milton Keynes was seen as the big city on the doorstep. The Thatcher years unsettled the naturally conservative outlook of Winslow people. It also brought in many affluent newcomers and drove up house prices. Council houses were sold off.

At one time, living down the council houses was almost a derogatory description. Suddenly such people were home owners with aspirations. However, in the long term, these bargain purchases created problems for young people trying to get on the property ladder. Others, from the comfort of their own substantial homes and with high incomes, formed groups to stop the town's historic character being overwhelmed by a sprawl of new housing. Quite rightly, they criticised the lack of infrastructure. Struggling traders meanwhile were concerned to stop a relief road from being built. People living on Magpie Farm and Elmfields were also concerned about a main road being diverted close to their back gardens. The term NIMBY (Not In My Back Yard) was born.

Such was the pressure on the county to accommodate government housing growth plans, there was a flurry of in filling. The old National School, which was still dealing with pupils up to the age of 15, in 1959, closed as a First School in the early 1990s. The Secondary Modern school, in Park Road, closed in 1988, following the Brisbourne Falling Rolls commission, headed by Richard Brisbourne. Figures used to justify this closure were clearly manipulated. During a protest meeting, the chairman of Buckingham Secondary Modern school actually admitted that his school was not ready to have Winslow and its catchment area of pupils transferred to Buckingham.

This was the new reality which Winslow and District were slow to grasp. Decisions were being made way over their heads. It was a town still lost in the memories when it was a centre of power, with its own Rural District Council, based at the Elms in Winslow High Street. It was an attitude summed up by the local *Buckingham Advertiser* in 1896: 'perhaps there is no town in North Bucks which so delights in figureheads as Winslow.... However....they are beginning to realise......they are expensive luxuries.'

Symbolically, as I write, the old cattle market is being demolished to make way for more houses. The old tanyard went a few years ago, the last blacksmith, working behind The Windmill pub, went years earlier. The town now faces the biggest challenge yet. There are plans by a group, registered in the Channel Islands, but involving local landowners, to develop the old wartime airfield adjacent to its boundaries.

The plan is for 3,500 new homes, offices and shops. As yet, there is no indication of an appropriate new infrastructure. Completion will take fifteen years and construction traffic will burden local roads. Moreover, it will link the settlements of Winslow, Little Horwood and Great Horwood. Meanwhile, Milton Keynes has the go ahead to double in size and expand in the direction of Little Horwood.

Developers say that reopening the railway line will ease traffic problems. Bucks County Council experts say that the railway will reduce the increased traffic by ten per cent at best. When it comes to development, the County Council has little, if any power to resist government targets. They are up against the argument that other parts of the Southeast face even greater problems of congestion and infra structure overload. Housing demand is rising in spite of recession.

Over time, Winslow has changed drastically, even though parts of it still look the same. Only recently the police posted a notice quoting the latest anti social order legislation to a lamppost in Sheep Street. It threatened troublesome individuals with things like community service. Reading it reminded me of watching the telly goons in the 1960s. In this Harry Seacombe's resounding voice was often heard, while a puppet version of him performed along with other goon puppets and voices. Seagoon, as his character was called, was often seen and heard threatening to shoot people with a photograph of a gun, Now thinking of that really takes me back in time.

The old way of life was well encapsulated by local photographer William Turnham (1878- 1932):

> In Winslow fields I sported as a boy,
> In Winslow found my greatest joy,
> A pretty girl became my wife
> Here I lived a happy married life,
> And hope when I am gone, and life is past
> To lay my bones in Winslow ground at last.
> My dear native town, what can compare
> With thee for pleasant site or wholesome air.
> No factory dims the sky with deadly smoke,
> No noisesome fogs thy happy children choke,
> No recking slums with pestilential breath
> Spread all around them, vice disease and death.
> So clear the sky, the lark sings overhead,
> So pure thy air, no pestilence we dread.

These lines were written for a competition at the Congregational schoolroom.

Acknowledgements

I give thanks to all of the people mentioned in this book and to others who have influenced my understanding of the town over the years. Special thanks are due to my late mother. She gave me her love of reading and encouraged me to write.